# THE ART OF
# STEAMPUNK

Extraordinary Devices and Ingenious Contraptions
from the Leading Artists of the Steampunk Movement

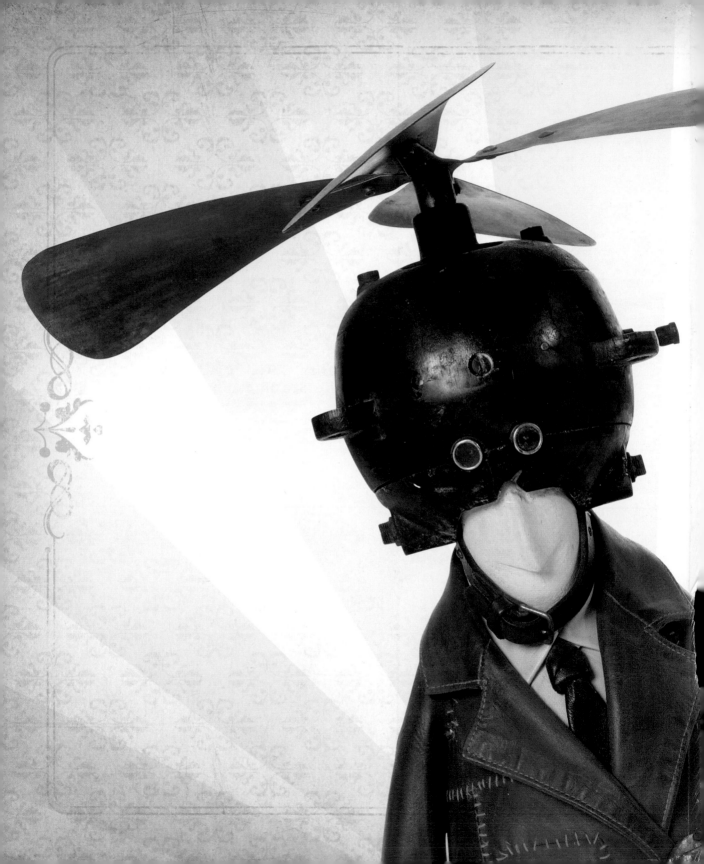

# THE ART OF
# STEAMPUNK

### Extraordinary Devices and Ingenious Contraptions
### from the Leading Artists of the Steampunk Movement

## Art Donovan

Foreword by Dr. Jim Bennett,
Director of the Museum of the History of Science,
Oxford University, Oxford

Featuring an essay by G. D. Falksen

FOX CHAPEL
PUBLISHING

"Steampunk creations may be mechanical, sculptural, or purely decorative. The designs may be practical or completely fanciful. Whatever the application, the art celebrates a time when new technology was produced, not by large corporations, but by talented and independent artisans and inventors."

ART DONOVAN, AUTHOR AND CURATOR

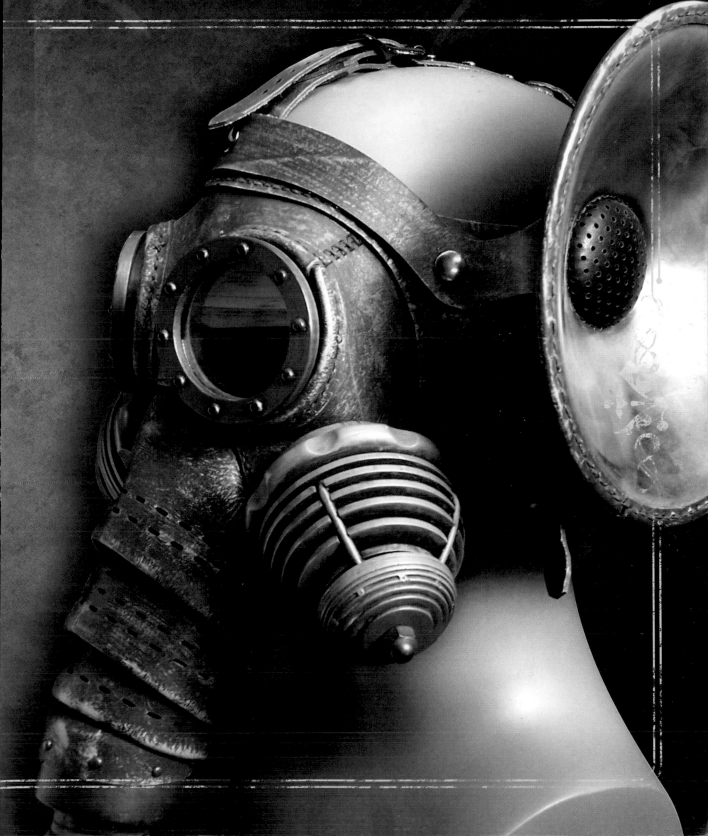

*The Art of Steampunk* is an original work, first published in 2011 by Fox Chapel Publishing
Company, Inc., East Petersburg, PA.

All images were taken and provided by the artists unless otherwise noted, and were
collected by Art Donovan.

The following essay was printed with permission: "Steampunk 101," page twenty-two,
G. D. Falksen.

The quote on page four originally appeared in the article "Steampunk Art and Design Exhibits
in the Hamptons," by Eileen Casey, Hamptons.com. Reprinted with permission.

ISBN: 978-1-56523-573-1

Library of Congress Cataloging-in-Publication Data

Donovan, Art (Arthur W.), 1952-

The art of steampunk / Art Donovan ; foreword by Jim Bennett. -- 1st ed.

    p. cm.

 Published in conjunction with an exhibition held at Oxford University's
Museum of the History of Science, Oct. 2009-Feb. 2010.

 Includes index.

 ISBN 978-1-56523-573-1

 1.  Art and technology--History--21st century. 2.  Art, Modern--21st century--Themes, motives.
3.  Technology in art. 4.  Steampunk culture. I. University of Oxford. Museum of the History of
Science. II. Title.

 N72.T4D66 2011

 709.05'1107442574--dc22

                       2011000752

To learn more about the other great books from Fox Chapel Publishing, or to find a retailer
near you, call toll-free 800-457-9112 or visit us at *www.FoxChapelPublishing.com*.

We are always looking for talented authors to write new books on woodworking, needle arts,
design, and crafts. Please send a brief letter describing your idea to Acquisition Editor,
1970 Broad Street, East Petersburg, PA 17520.

Printed in China
First printing: August 2011

## Dedication

With love, for my beautiful wife, Leslie Tarbell Donovan, without whose talent and vision, this exhibition and book would not have been possible.

## Acknowledgements

I would like to acknowledge the generous support of the following individuals and organizations and thank them for their gracious support.

- *Anne Surchin, American Institute of Architects*
- *The American Hotel*
- *Barber-Wilson Co, UK*
- *Bethany Peters*
- *Carleen Ligozio*
- *Cory Doctorow*
- *Deidre Woolard*
- *Dr. Jim Bennett, Director, Museum of the History of Science*
- *The Hamptons Antique Galleries*
- *Joanne Molina*
- *Laura Ashby, Museum of the History of Science*
- *Lauren Sloan Weisman*
- *Sam Van Olffen*
- *Sara Brumfield*
- *Sydney Padua*
- *Margaret Hauser, Museum of the History of Science*
- *Nick and Owen, Museum of the History of Science*
- *Nick Ottens*
- *The Sag Harbor Yacht Yard*
- *Whites Pharmacy*

# Contents

# ABOUT THE AUTHOR

Art Donovan

*Art Donovan was born and raised in New York City. With more than thirty years of experience in the art industry, Donovan was once the senior designer and head illustrator for Donald Deskey Associates, the company responsible for designing the interior of Radio City Music Hall. Since 1990, Donovan has worked for Donovan Design, a company he and his wife, Leslie, founded. Donovan creates handcrafted lighting fixtures and illuminated sculptural objects for the company. The Donovans have an impressive client list that includes groups and companies such as Tiffany & Co., New York City; The University of Baltimore, Maryland; Churchill Downs, Kentucky; Benetti Luxury Yachts, Italy; St. Francis of Assisi Cathedral, Nevada; Four Seasons Resorts Villas, St. Thomas; Nine Zero Hotel, Boston; and Disney Cruise Lines, along with countless private residences, restaurants, and casinos around the world.*

**Opposite** *Siddhartha Pod Lantern,* 2008, 62" x 23" (1575 mm x 585 mm), mahogany, glass, and brass. This piece was Donovan's first Steampunk creation.

Donovan first encountered Steampunk on the Internet a few years ago. He was excited by the style because it was like nothing he had ever seen before, and focused on topics such as history, science, and science fiction, subjects in which he has always held an interest. Donovan soon began designing Steampunk light fixtures, embracing the style that was so far removed from anything he had ever done previously.

Donovan's interest in Steampunk did not end with his creation of new projects. Instead, it led him to make connections with other Steampunk artists and, eventually, to become the curator of a Steampunk exhibit at the Hamptons Antique Galleries in 2008 and the Steampunk exhibition held at Oxford University's Museum of the History of Science. The exhibition, which ran from October 2009 to February 2010, brought together renowned Steampunk artists from around the world. Since the exhibition, Donovan has continued to create Steampunk masterpieces and is constantly working to bring Steampunk to the attention of others.

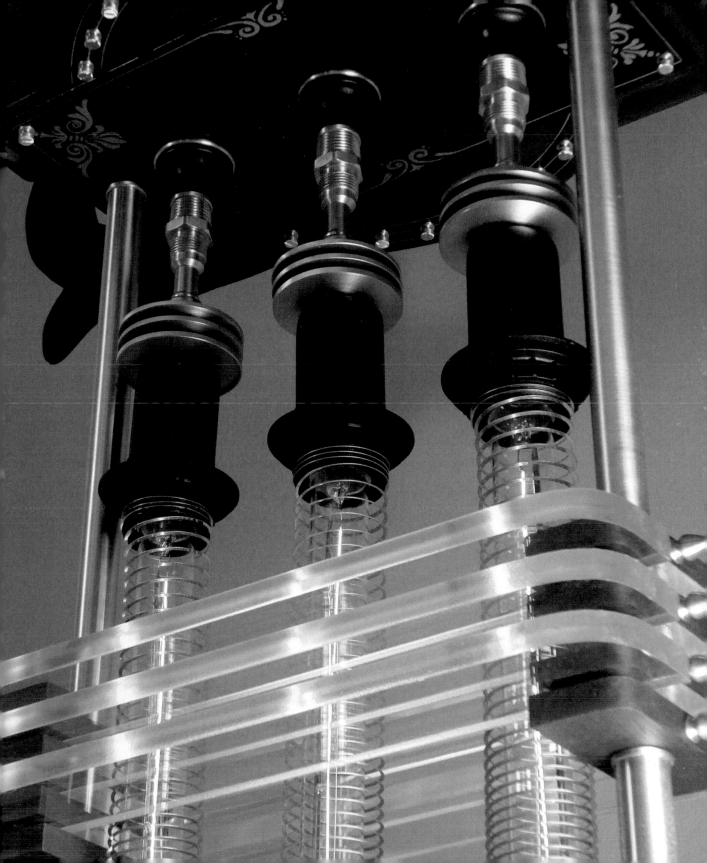

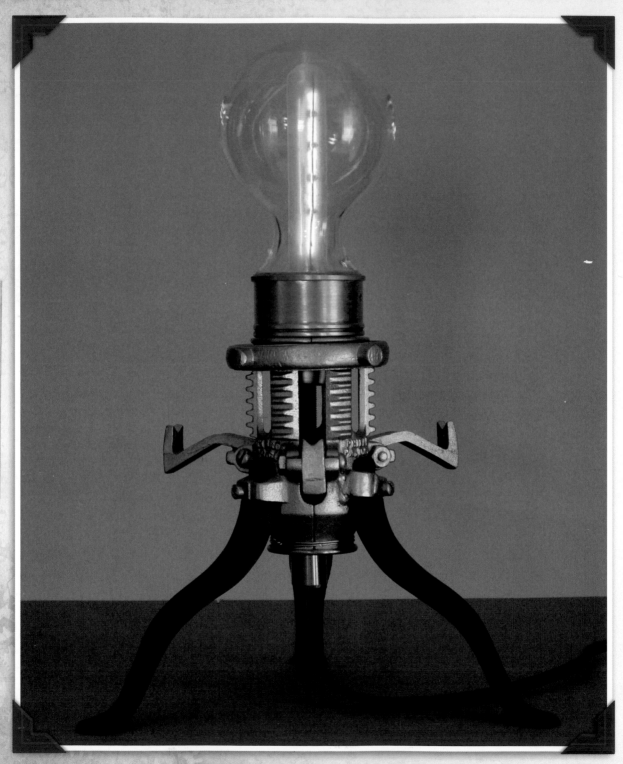

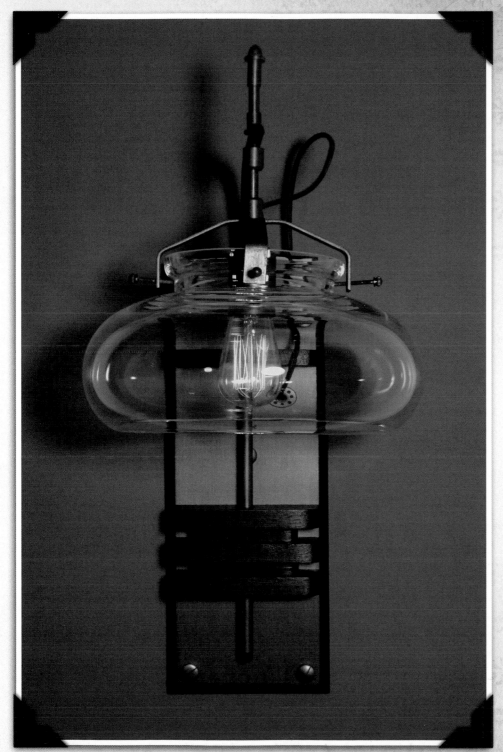

**Opposite** *Mr. Peanutski*, 2008, 13.5" (340 mm) tall, brass, steel, modded light bulb.

**Left** *Oxford Station Lantern*, 2010, 18" x 13" (455 mm x 330 mm), antique satin brass, mahogany, steel, hand-blown glass globe. This Steampunk lamp is inspired by the lamps found outside of New York City's Grand Central Station.

13

14

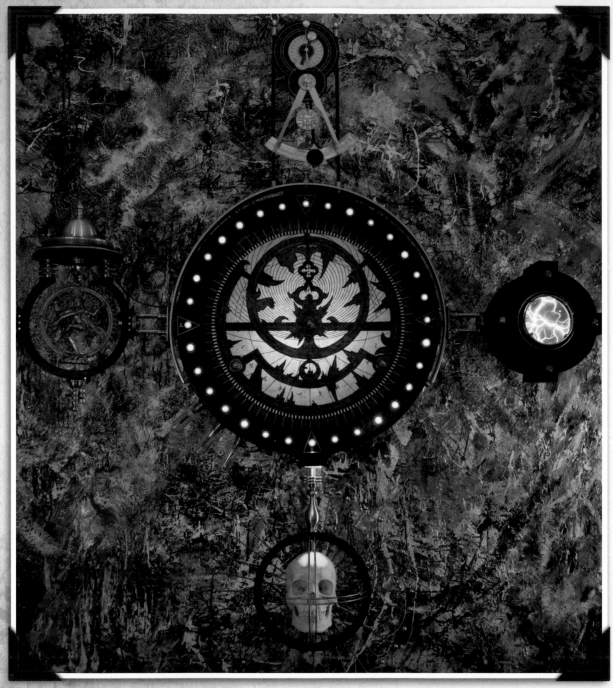

*Shiva Mandala,* 2009, 72" x 72" (1830 mm x 1830 mm).
Representing the cycle of life, the *Shiva Mandala* is
made up of five distinct pieces: the center *Astrolabe*
and four surrounding "planets."

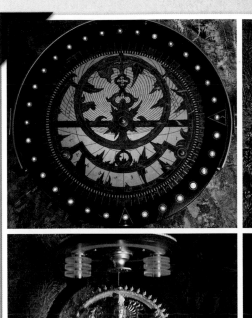

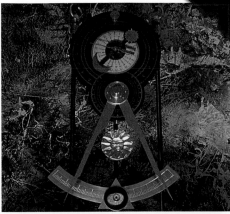

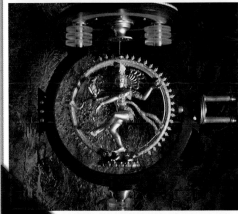

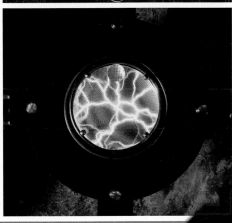

**Top Left** *Astrolabe*. The *Astrolabe* is the central piece of the *Shiva Mandala* and is a reproduction of a thirteenth century Persian device.

**Top Right** *All Seeing Eye*. The upper planet of the *Shiva Mandala* contains Masonic symbols.

**Middle Left** *Nataraja Shiva*. Donovan created this planet of the *Shiva Mandala* so that it slowly rotates.

**Middle Right** *Plasma Disk*. The electric blue *Plasma Disk* is the right-hand planet of the *Shiva Mandala*.

**Bottom** *Craniometer*. The *Craniometer* is the lower planet on the *Shiva Mandala*.

15

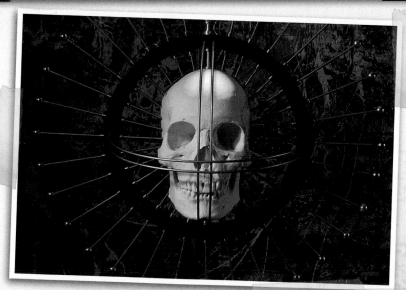

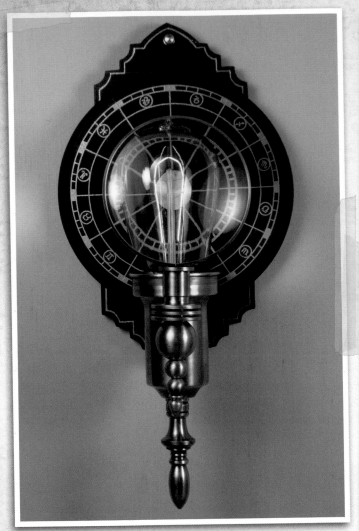

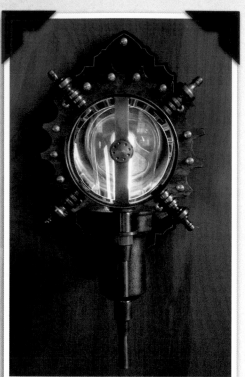

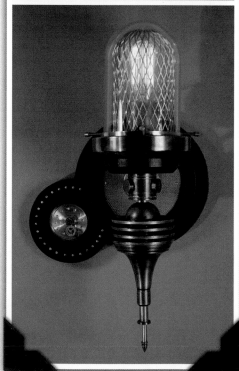

**Above** *Parrish Carriage Lantern*, 2008, 18" x 11" (455 mm x 280 mm), brass, mahogany. This lantern features hand-painted symbols to add a unique detail.

**Above Right** *Sister to the Parrish Carriage Lantern*, 2008, 18" x 11" (455 mm x 280 mm). This lamp is a twist on the *Parrish Carriage Lantern*, featuring more ornate and machine-like elements.

**Right** *Parrish Carriage Lantern III*, 2008, 18" x 11" (455 mm x 280 mm). The third lamp in the *Parrish Carriage Lantern* series displays a clock at its base.

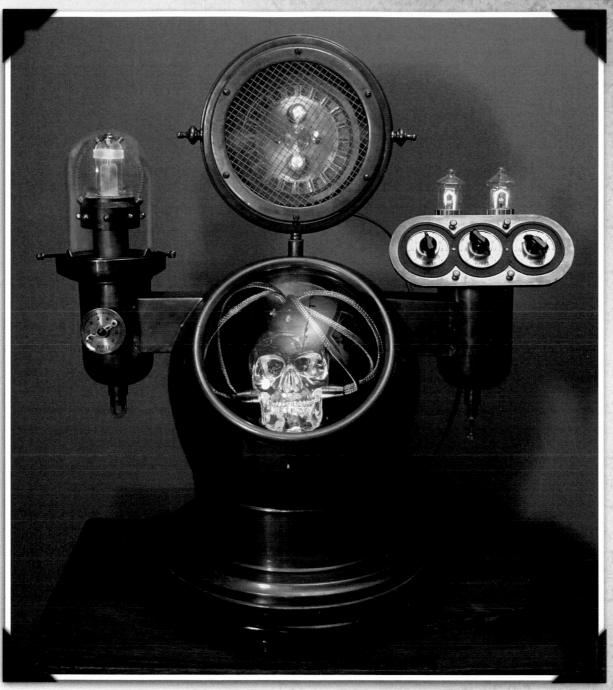

*The Electric Skull*, 2009, 24" x 24" (610 mm x 610 mm). Donovan took inspiration for this piece from a nautical compass-like device often found on Victorian ships.

# FOREWORD

**Top Right** This program was handed out to guests attending the Oxford Steampunk exhibit.

**Bottom Right** More than 70,000 visitors walked through the entrance of the Museum of the History of Science to view the Steampunk exhibit.

When Art Donovan suggested an exhibition of Steampunk art at the Museum of the History of Science, we quickly realized that here was an opportunity not to miss. Many science museums today emphasize the importance of their work for the public understanding of contemporary science. This is a policy we have difficulty following, because the material we preserve and display is renowned for its antiquity. While, as historians, we believe that the present depends on the past and cannot be fully appreciated without a historical perspective, we are also aware the understanding of the material world in the past could be profoundly different from ours. Interpreting this past understanding in terms of modern science can be deeply distorting.

Because the original intellectual context for much of our collection is often unfamiliar to visitors, and a modern interpretation often inappropriate, we try to emphasize the value of a variety of approaches and appreciations. We can be more relaxed about understanding "the science" than many museums, seeing this as only one possible approach, while others might be aesthetic, social, historical, biographical, cultural, and so on. We want visitors to enjoy our objects in a variety of

ways and not to feel alienated if the theoretical content of the science is not for them. We want them to value what they enjoy about engaging with our remarkable collection.

So, a Steampunk exhibition was perfect. Engagement with the aesthetic aspects of science, past and present, had already led us to a strong art component in our exhibitions and to a current in our program branded as "ART@MHS." Steampunk brought two additional features. First, the movement had adopted a visual culture originally exemplified by many of our instruments. Second, Steampunk had brought these aesthetic, material, and artisanal values enthusiastically into the present day. We quickly realized Steampunk did not aim at a nostalgic recreation of a vanished past and its devices were both imaginative and contemporary. So the exhibition could be an opportunity to achieve that elusive combination we sought—historical appreciation and contemporary relevance.

The emphasis of this book is properly on the Steampunk art from the exhibition and on the artists who made it, but the museum added a component to the show that made the most of the opportunity we

18

had recognized. A room through which the visitors exited contained original Victorian and Edwardian instruments and machines that exemplified the roots of Steampunk art. The reactions of our visitors supported the museum's policy of the varieties of appreciation. Objects that would scarcely have been noticed elsewhere in the museum were examined with care and pleasure. Instruments that would have been dismissed as beyond understanding were embraced for their sculptural and decorative qualities; they were enjoyed as relics of a past visual culture. In the gallery devoted to Steampunk art, the visitors had engaged easily with the display, had savoured and valued the pleasure of seeing work that was thoughtful, original, finely made, and amusing, and they carried that sensibility into the gallery of historic instruments. No amount of exhortations from us about varieties of appreciation could have achieved this, but here we could see the policy working. Steampunk gave us that opportunity.

— **Jim Bennett**
*Director, Museum of the History of Science, Oxford University, Oxford.*

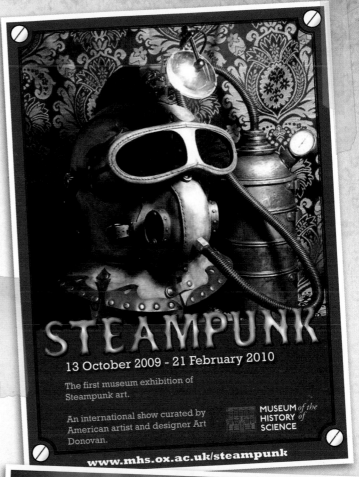

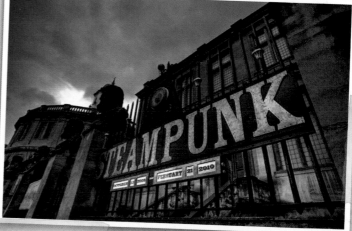

PHOTO BY SHANE HICKS

19

**Right** The Museum of the History of Science created a special sign that was added to the entrance to the museum while the Steampunk exhibit was running.

**Below** From October 2009 to February 2011, visitors to the Museum of the History of Science could walk through Steampunk-themed galleries and attend special events. This program shows the list of events for October through December 2009.

**Opposite** Designed by Art Donovan, this poster was used to advertise the exhibit.

20

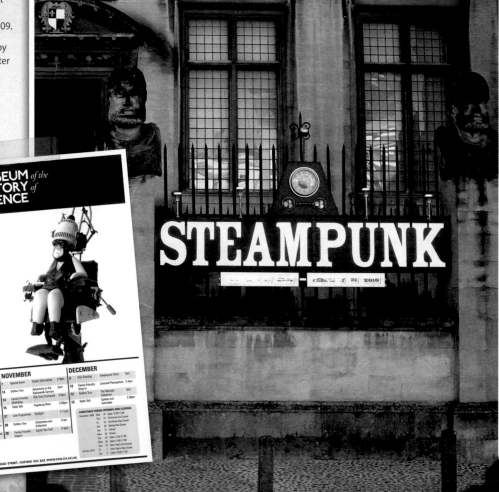

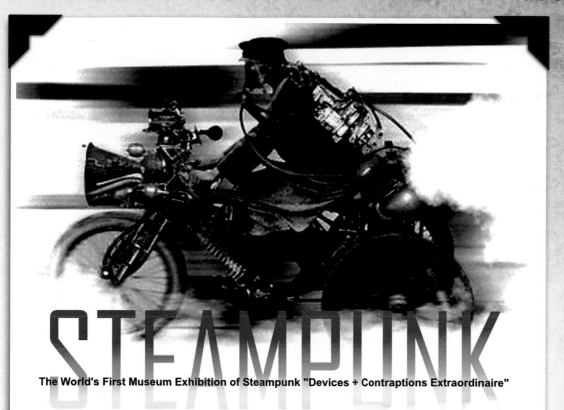

# STEAMPUNK

**The World's First Museum Exhibition of Steampunk "Devices + Contraptions Extraordinaire"**

**The Museum of the History of Science at the University of Oxford, UK**

## October 13, 2009 through February 21, 2010

Artists hailing from:
Japan
Canada
Belgium
Australia
Switzerland
The Netherlands
The United States
The United Kingdom

**Presented by Dr. Jim Bennett and Curated By Art Donovan**

www.steampunkmuseumexhibition.blogspot.com

Art by Sam Van Olffen

22

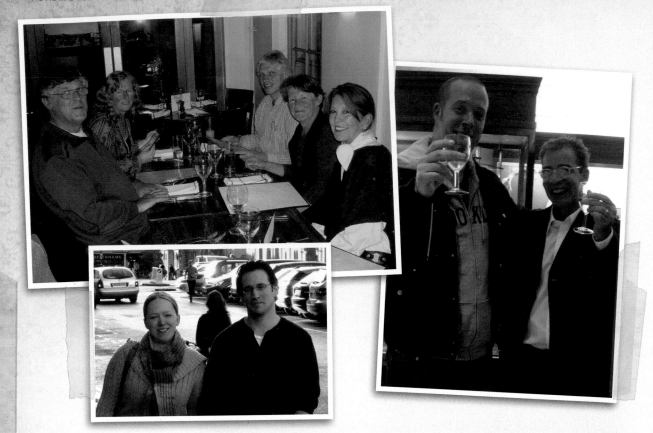

**Above Left** Artist Jos de Vink (left) celebrated the success of the exhibition at a dinner with his family, fellow artist Art Donovan, and Donovan's wife, Leslie (bottom right).

**Above Right** The exhibit showcased artists from around the world, such as Stephane Halleux (left) from Belgium and Art Donovan (right) from the United States.

**Above Middle** Eric Freitas, pictured here with his wife, Sarah, displayed several of his Steampunk clocks at the exhibition.

**Right** Artists Tomas Willeford (right) and Amanda Scrivener (center) presented individual and collaborative pieces at the Oxford exhibition.

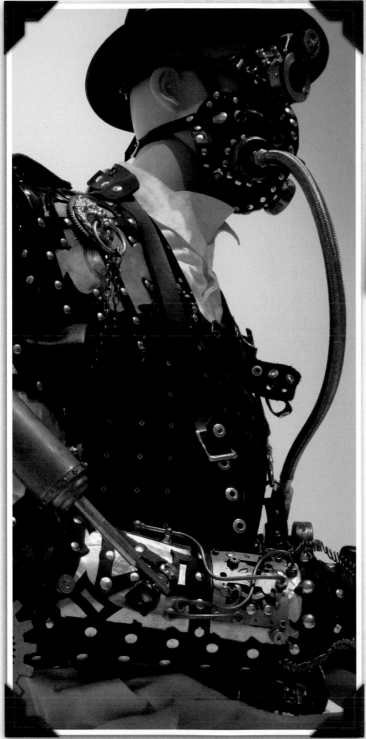

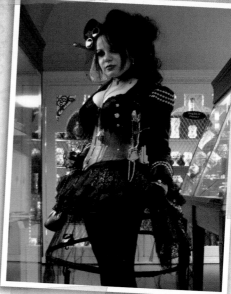

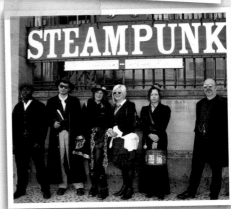

**Left** This piece, on display at the Steampunk exhibition, was created by Thomas Willeford and Amanda Scrivener.

**Top** The exhibit not only showcased Steampunk art and design, but some Steampunk fashions as well.

**Above** In the spirit of the exhibition, many Steampunk fans came to the museum dressed in costume.

# INTRODUCTION

From October 13, 2009, to February 21, 2010, it was my great honor to act as curator for the Steampunk exhibition held at the University of Oxford's Museum of the History of Science. The event was the first museum exhibition of Steampunk art ever, and featured work from eighteen of the most renowned Steampunk artists from around the world. More than 70,000 guests arrived at the museum during the exhibition's four-month span to attend lectures, workshops, and holiday events that all revolved around Steampunk.

For Steampunk enthusiasts, an event with the magnitude of the Oxford exhibition has been a long time coming. Although most people have never heard of it, on the Internet, Steampunk has grown so wildly popular that, in less than a year, it has spawned an actual philosophy and lifestyle among its fan base. Steampunk has already influenced everything from product design to fine art and fashion.

Steampunk is a unique fantasy version of nineteenth century Victorian England, now imbued with high-tech digital devices, fantastic steam-powered machines, and all manner of surreal electro-mechanical contraptions that could only have been conjured by a mad twenty-first century scientist. The "steam" refers to steam power—as in the living fire-breathing machines of antique locomotion. The "punk" is an important reference to an outsider attitude. In Steampunk, this attitude manifests itself in the form of the lone wolf artist, the Do-It-Yourself (DIY) craftsman, and the amateur engineer, who are not beholden to any contemporary style or ideology. You can bet you won't be seeing this kind of design in your

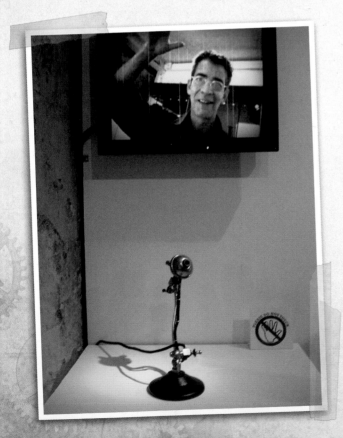

next *Design Within Reach* catalog—and that's just the way the Steampunks want it.

Once you know where to look, Steampunk design is familiar. By reading H. G. Wells, Jules Verne, or Mary Shelly, or by seeing movies such as *Brazil* or *The League of Extraordinary Gentleman*, you may already have had a peek into this ingenious style. Hollywood has embraced Steampunk and often uses it as a plot foundation for its films (think *Wild, Wild West*). As far as Steampunk's Internet popularity is concerned, you can thank today's young savvy computer geeks, bloggers, gamers, authors, and artists. Obviously, these creative individuals are not Luddites. They celebrate modern technology, but firmly believe that the design of modern products like the iPhone and iPod can't possibly compete with the luxurious design of the early "Victorian wonders" of technology.

Although it's technocentric in styling, Steampunk design is definitely not just a "boy's club" of enthusiasts. Its fans and creators are equally divided among women and men, young and old alike, from around the world. Websites dedicated to the style, such as Sara Brumfield's *The Steampunk Home*, feature the most current "New Victorian" designs applied to everything from architecture and product design to home accessories.

No longer satisfied with the injection-molded plastic design of today's mass-produced products, Steampunk artists are crafting a romantic new standard for modern goods by taking traditional nineteenth century materials and applying them to twenty-first century technology. They reach to the past and the future, combining elements of both into designs that are richly pleasing to the eye and as technologically up to date as the latest computers, music players, and stereo systems. These artists prefer the "transparent" honesty of the handcrafted object, and—with a surprising disregard for the *de rigueur* styling of contemporary fashion—they boldly

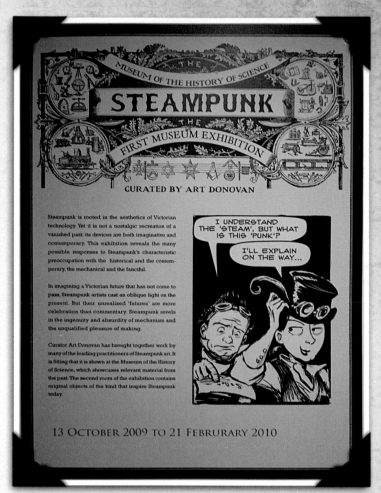

**Above** This sign was hung at the entrance to the Steampunk exhibit, and helped visitors who might be encountering Steampunk for the first time gain some understanding of the style.

25

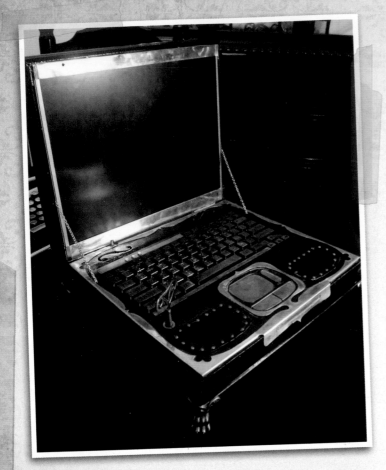

turn the laptop on. With a few twists of the key—accompanied by the anticipated and satisfying clicking sound—Nagy's laptop fires up to perform as well as the best state-of-the-art computers on the market.

These computer designs, as unique and beautiful as they are, beg the obvious question: Why would anyone want to design a computer or laptop to look like this in the first place?

In the world of Steampunk, machines must not only be practical, they must be pieces of art. During the Victorian era, objects were not only meant to be impressive in function, but in form as well. Steampunk art seeks to continue this philosophy by celebrating the object that is created. In the mind of a Steampunk artist, a computer should not only operate at the highest speed possible, it should be richly decorated with the finest woods and metals. Music from an iPod should not be heard through plastic headphones, but should be projected through a shining brass gramophone horn.

It is true, due to the modern methods of mass production and the need to cheaply produce billions of units, modern design now suffers from an androgynous "digital silhouette" whereby one cannot visually tell the difference between a cell phone and a remote, or even a flat screen TV and computer. To counter the current generic look of modern products, Steampunk artists spend hours handcrafting their pieces so that each one takes on its own style and flavor. This dedication to unique

26

**Above** *Datamancer Steampunk Laptop*, Richard Nagy, 2007, 14" x 16" (355 mm x 405 mm), wood, brass, copper, clock gears, glass.

**Right** *Antiqua Perpetual Calendar*, Vianney Halter, 1998, created at La Manufacture Janvier (Sainte-Croix), 1.6" (400 mm) diameter, .5" (110 mm) thick, rose gold.

embellish their work with all manner of historic design references and ornate technological flourishes.

Richard Nagy, whose stunning work can be found within the pages of this book, creates modded laptops that are techno-logical Steampunk jewels. Imagine sitting in Starbucks and opening up one of Nagy's slim solid mahogany laptops, complete with studded leather hand rests, brass scroll work, elegant cast-claw feet, and solid brass antique keys. For added authenticity, Nagy provides a large antique key that is actually used to

individuality can be seen in everything from handmade piston-driven contraptions to exquisitely rendered fantasy devices and designs in exotic woods and gold.

It's important to realize, however, that Steampunk design is not simply relegated to fashionable decorations and digital devices. Jos de Vink, an artist and mechanical engineer

> ## "Steampunk design is not simply relegated to fashionable decorations and digital devices."

Steampunk is such a wide and democratic philosophy with influences of fantasy literature, Victorian science, and nineteenth century spiritualism, that there is no single way to approach Steampunk art and design. Whether they're decorative or utilitarian objects, however, Steampunk designs are individual artisan creations. They are, intrinsically, sculptural pieces of art and lend themselves to any environment, be it extreme contemporary or traditional.

Swiss timepiece master Vianney Halter, who presented his collection of Steampunk watches at the Oxford exhibition, has demonstrated how seriously Steampunk has influenced even the most traditional of design disciplines. Halter's wristwatch, *Antiqua Perpetual Calendar*, is a handcrafted relic of the future, complete with multiple gauges and a sapphire crystal back that displays the clock works. The watch, which took Halter more than 900 hours of intense labor to produce, looks as if it has been taken from the cockpit of an antique locomotive.

from the Netherlands whose work can also be found on the pages of this book, is currently experimenting with motors and engines that run solely on heat. His Steampunk Stirling engines are beautifully handcrafted from solid brass and use the simple heat from a candle or tea light to power their piston-driven motors. Using only the small differential of hot and cold

27

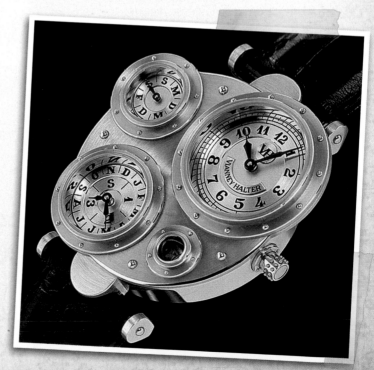

air as power, de Vink's magnificent Steampunk engines are a true miracle of silent locomotion in an elegant physical form.

Steampunk, with all its varied manifestations, is not merely an odd new trend, but is destined to have a rich and exciting life. The Oxford exhibition clearly demonstrates the growing impact Steampunk has had on the art and design world. It served as

the Steampunk genre and had been working in the style for years. Other artists had been "adopted" by the devotees of Steampunk. That is to say, those artists' works were considered genuine Steampunk, but were not created with the genre specifically in mind.

Although the doors to the Steampunk exhibition are now closed, this auspicious event is now commemorated and celebrated

> "Steampunk has already influenced everything from product design to fine art and fashion."

a perfect introduction to both the artists' works and the historic influences that have ignited the Steampunk genre on a global scale by presenting Steampunk artwork side-by-side with the museum's collection. This juxtaposition allowed viewers to gain a fuller appreciation for the artists' aesthetic intentions and the historic scientist's practical motivations. By way of this direct comparison, the opaque window of creative inspiration became clearer, and valuable connections between the visual arts and the physical sciences were forged.

The exhibition also showcased the diversity that is such a celebrated part of Steampunk philosophy. The artists who presented their work at the museum arrived from vastly different backgrounds and careers. Some had devoted themselves entirely to

in book form, utilizing exquisite photographs of the artwork presented at the museum to bring the exhibition to those who are only just discovering Steampunk. This book is a tribute to Steampunk's inherent ability to grow into a variety of exciting disciplines and to actively reinvent itself by reaching back to our past to claim the most wondrous parts of history, overlooked technologies, and design.

Captain Nemo would be proud.

—Art Donovan

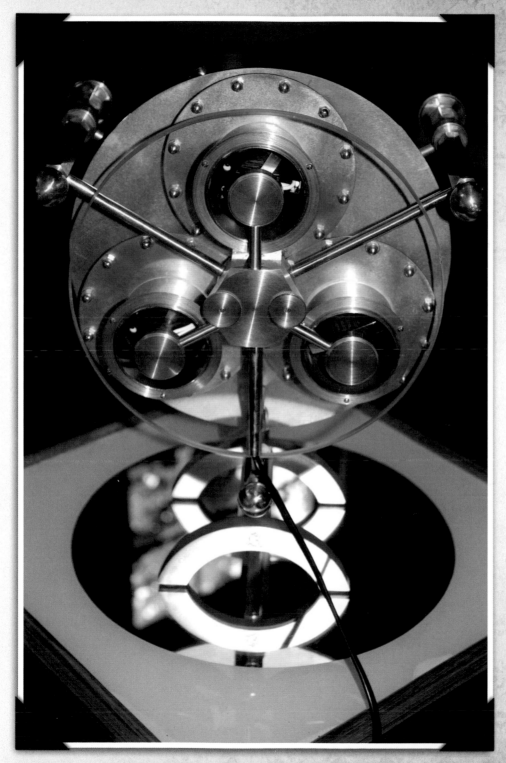

**Left** *The Flying Saucer*, Jos de Vink, 2008, 12" x 8" x 14" (300 mm x 200 mm x 380 mm), brass, bronze, stainless steel, Plexiglas.

# STEAMPUNK 101

By G. D. Falksen

### What is Steampunk?

In three short words, Steampunk is Victorian science fiction. Here, "Victorian" is not meant to indicate a specific culture, but rather references a time period and an aesthetic: the industrialized nineteenth century. Historically, this period saw the development of many key aspects of the modern world—mechanized manufacturing, extensive urbanization, telecommunication, office life, and mass transit. Steampunk uses this existing technology and structure to imagine an even more advanced nineteenth century, often complete with Victorian-inspired wonders like steampowered aircraft and mechanical computers.

### Where did Steampunk come from?

In some sense, Steampunk has existed since the nineteenth century. The Victorian period had its own science fiction, perhaps most famously embodied by the works of Jules Verne and H. G. Wells, and throughout the twentieth century, there have been science fiction stories set in the Victorian period. The term "Steampunk" was not coined until the late-1980s, however, when author K. W. Jeter used it humorously to describe a grouping of stories set in the Victorian period and written during a time when nearfuture cyberpunk was the prevailing form of science fiction.

### Where does the Sci~Fi come in?

The line between Steampunk and period Victorian is extremely narrow, and often the two are indistinguishable. They are separated

only by Steampunk's status as science fiction, albeit heavily inspired by the historical facts of the Victorian period. This is generally accomplished in one of two ways. The "protoSteampunk" stories of the nineteenth century can be seen as a parallel to our own science fiction; that is, a view of the future from the present. For the Victorians, this meant imagining a future that looks dramatically unmodern to modern eyes. Submarines, space travel, aircraft, and mechanized life were all imagined by the Victorians, but while some of these came very close to the mark, they still differed from where the future actually went. For modern writers, with the benefit of modern science, Steampunk becomes a reimagining of the nineteenth century with a view of where science will one day go. In this way, Steampunk often works to translate modern concepts such as the computer revolution, spy thrillers, noir mysteries, and even the Internet into a Victorian context using Victorian technology. Steampunk becomes the perfect blending of alternate history and science fiction.

## Where does steam come in?

Steampunk's steam references more than simply the technology itself, although steam engines are a vital aspect of life in a Steampunk world. Steam more generally signifies a world in which steam technology is both dominant

and prolific. During the Victorian era, steam power revolutionized almost every aspect of life. The steam engine made full-scale industrialization possible and produced mechanical power more efficiently and to greater degrees than human and animal labor could manage. Mechanized manufacturing and farming caused an upheaval in the structure of working life, but dramatically increased society's productivity and freed up an entire group of individuals to form the modern class of professionals and office workers. The changes in society brought on by steamdriven industrialization allowed for the unprecedented developments in science, society, and goods that came to be associated with the Victorian era. Steampunk takes inspiration from these changes and applies them to whatever culture it influences.

## Where does the punk come in?

Ironically, it doesn't. As was mentioned earlier, the term Steampunk is a tongue-in-cheek reference to the cyberpunk genre rather than a reference to the punk subculture. Moreover, "punk," in the context of punk rock, was the product of very specific circumstances following the Second World War, which makes

**Opposite** *Oxford Station Lantern*, Art Donovan, 2010, 18" x 13" (455 mm x 330 mm), antique satin brass, mahogany, steel, hand-blown glass globe.
**Above** *Steampunk Tripod Floor Lamp*, Art Donovan, 2008, 60" (1524 mm) tall, solid mahogany, pine, brass, acrylic, glass.

it fundamentally distinct from the Victorian aesthetic that inspires Steampunk. Individuals interested in exploring a Steampunk equivalent to twentieth century punk, however, can find a wealth of material in nineteenth century counterculture groups ranging from the Luddites to utopians to hooligans. Add a dash of Victorian street culture and a sprinkling of ragtime and Steampunk "punk" comes into focus.

## What about gears?

The gear is an easily recognized symbol of Steampunk, but it is not unique to the genre. It was invented long before the nineteenth century and it remains in use today. The gear in Steampunk joins related devices such as flywheels and pistons as the "power lines" of the steam age. Steam power is mechanical power and its transmission demands a network of moving parts in the same way that electrical power transmission demands wires. The gear on its own is not especially Steampunk, but when put to use in nineteenth century machinery, it becomes a key icon of the genre.

**Below** *Steampunk Clock*, Art Donovan, 2008, 7" x 8" x 3" (178 mm x 203 mm x 76 mm), weathered brass, magnifying glass.

## What about goggles?

Goggles are often encountered in Steampunk clothing and imagery. This can create the misleading impression that they are somehow fundamental to the Steampunk "look." Although goggles are associated with both science and mechanized travel, both of which are common themes in Steampunk, this does not mean that everyone in a Steampunk setting wears goggles. In fact, only people who have a reason to wear them do so and then only while it is useful. As with scarves, driving coats, aprons, and overalls, goggles are a piece of fashion that can help give life to a Steampunk world when used properly and in moderation, but can rapidly border upon the ludicrous when turned into an end rather than a means.

## What is the appeal of Steampunk?

A genre as large as Steampunk has a wide-ranging appeal. Some people are drawn to it from a love of the Victorian period. Others enjoy Steampunk's unique approach to technology: reimagining modern capabilities with nineteenth century machines. Many people are drawn to it in light of its fashion aspects, which allow them to sample and even combine a range of clothing styles and accessories from across the nineteenth century world. One critical aspect of Steampunk is the tremendous diversity of appeal it presents,

which allows it to offer something for just about everyone. Steampunk is also aided by a more general neovintage movement, which has been steadily progressing through mainstream fashion, film, and aesthetics. But even this cannot wholly explain Steampunk's appeal. The genre possesses a life of its own that draws in fans from countless directions and backgrounds into a world where fashion is tailored to the individual, goods are made to last, and machinery is still regarded as a thing of visual majesty.

## Steampunk sounds great! Where's an easy place to start?

The basic rule of thumb for Steampunk is "start period and then add." One of Steampunk's great advantages is that the period by which it is inspired, the Victorian era, saw the invention of photography and cinematic film. These, in turn, allowed for a visual record of people from all different classes, cultures, and backgrounds, providing an unprecedented amount of reference material. People looking for fashion ideas, character inspirations, or scenes to describe can find a wealth of starting points in the countless vintage photographs and film reels left over from the nineteenth century. All that remains is to add to or modify the depictions to taste, though it must be remembered that many aspects of

a Steampunk world and its people will likely remain virtually indistinguishable from the period that inspires them.

## About the Author

G. D. Falksen is an author, lecturer, public speaker, and master of ceremonies. He also studies history and blogs for Tor.com. While his repertoire spans a range of topics, he is most noted for his Steampunk work and is one of the most recognizable figures in the Steampunk literary genre and related subculture. His fiction includes "The Strange Case of Mr. Salad Monday" and the serials "An Unfortunate Engagement" and "The Mask of Tezcatlipoca." His work has appeared in *Steampunk Tales*, *Steampunk Magazine*, *The Chap*, *Egophobia*, and the anthologies *Footprints* and *Steampunk Reloaded*. He has made appearances as a guest at various events, including Dragoncon and the World Steam Expo, and has appeared in the *New York Times*, the *San Francisco Chronicle*, the *Hartford Courant*, *Marie Claire Italia*, *Time Out New York*, and *New York Magazine*. He has also appeared on MTV, NHK, and VBS.TV. He is the lead writer for the video game *AIR*, a Steampunk-themed MMORPG currently in development by Hatboy Studios, Inc.

G.D. Falksen
Photo by Anna Fischer

# The Artists

**36**

**AMANDA SCRIVENER**
London, England

**44**

**THOMAS WILLEFORD**
Harrisburg, Pennsylvania,
United States

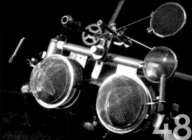

**48**

**CLIFF OVERTON**
Bundoora, Victoria, Australia

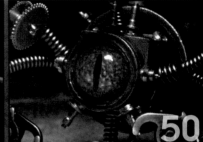

**50**

**DANIEL PROULX**
Montreal, Quebec, Canada

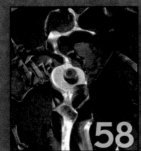

**58**

**ERIC FREITAS**
Royal Oak, Michigan,
United States

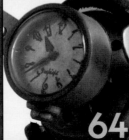

**64**

**HARUO SUEKICHI**
Tokyo, Japan

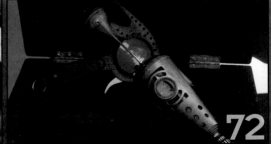

**72**

**IAN CRICHTON**
Woking, Surrey, United Kingdom

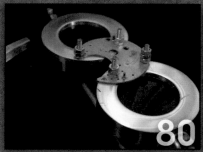

**80**

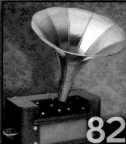

**82**

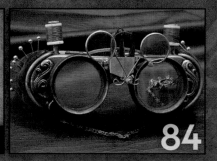

**84**

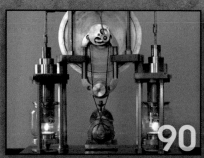

**90**

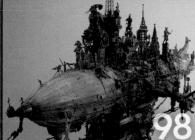

**98**

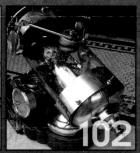

**102**

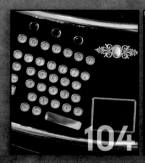

**104**

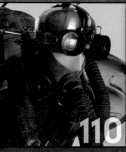

**110**

**116**

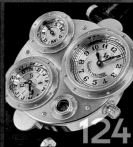

**124**

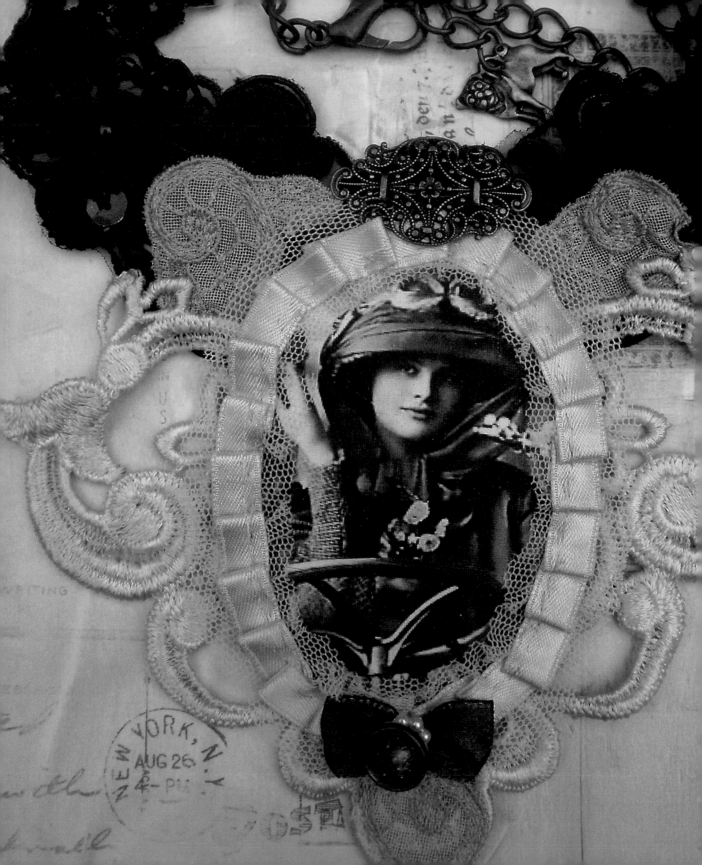

# Amanda Scrivener

## PROFESSOR ISADORA MAELSTROMME
### London, United Kingdom

Photo by Martin Small

Opposite *Early Era Lady Automobile Driver Lace Choker*, 2010, lace, chains, photograph.

Amanda Scrivener is a well-known designer of wearable pieces of art whose work is clearly unique. After attending two art colleges to study textiles, jewelry design, and jewelry production, Mme. Scrivener's work became inspired by the shadowy side of Victorian England. As her creator persona Professor Maelstromme, she crafts items in her laboratory that will bring to mind romance by gaslight, arcane science, the steam age, carnival sideshow curios, and aged materials from the vaults of the Victorian past. She loves working with pocket watches and wind-up clocks, often cannibalizing them for parts. Mme. Scrivener's creations (often designed in collaboration with Thomas Willeford) have been hailed as imaginative oddities that masterfully epitomize the diverse landscape of Steampunk design.

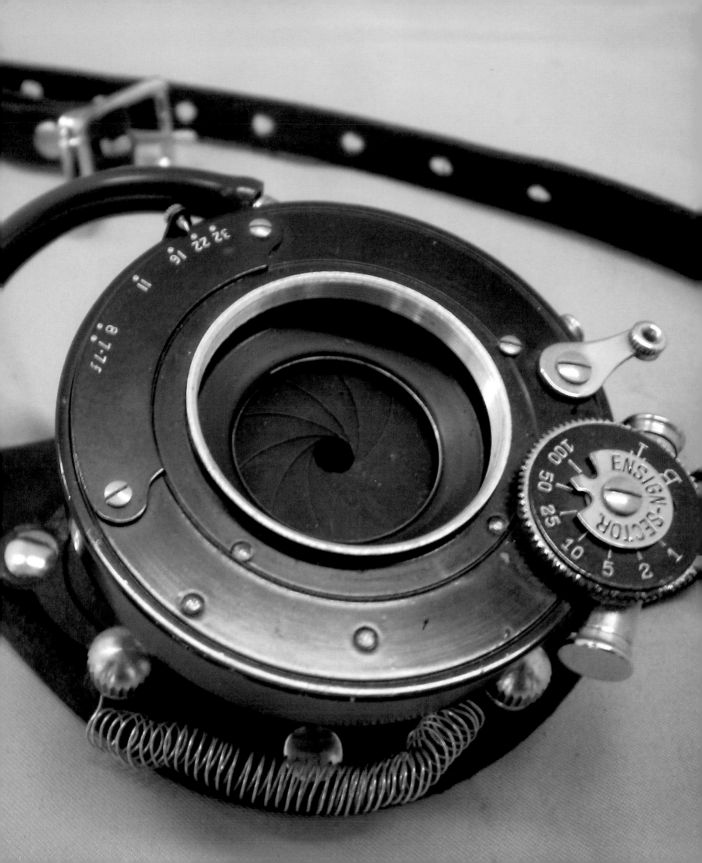

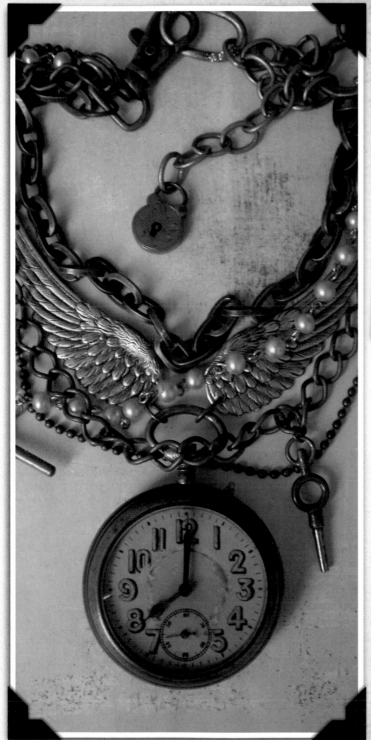

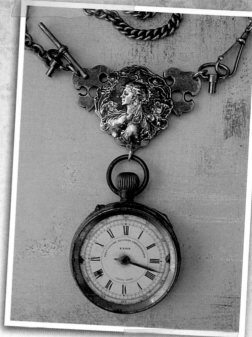

**Opposite** *Old Camera Lens Monocle*, black and burgundy leather, camera lens.

**Left** *Watch Chains Steampunk Inspired Necklace*, 2010, old pocket watch, old pocket watch chains.

**Above** *Old Pocket Watch Necklace*, 2009, pocket watch, pocket watch chains and clasps.

40

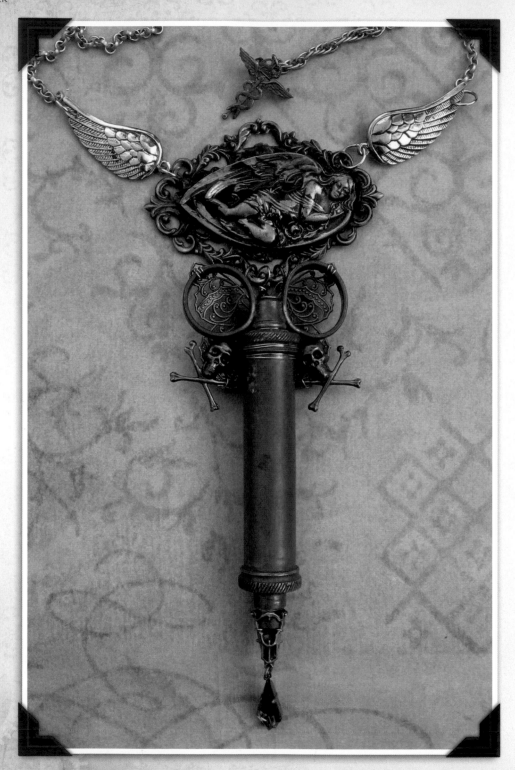

**Right** *Old Syringe Necklace*, 2009, brass syringe, chains.

**Opposite** *Winged Old Broken Pocket Watch Necklace*, 2009, broken pocket watch frame, silver ornament, chains.

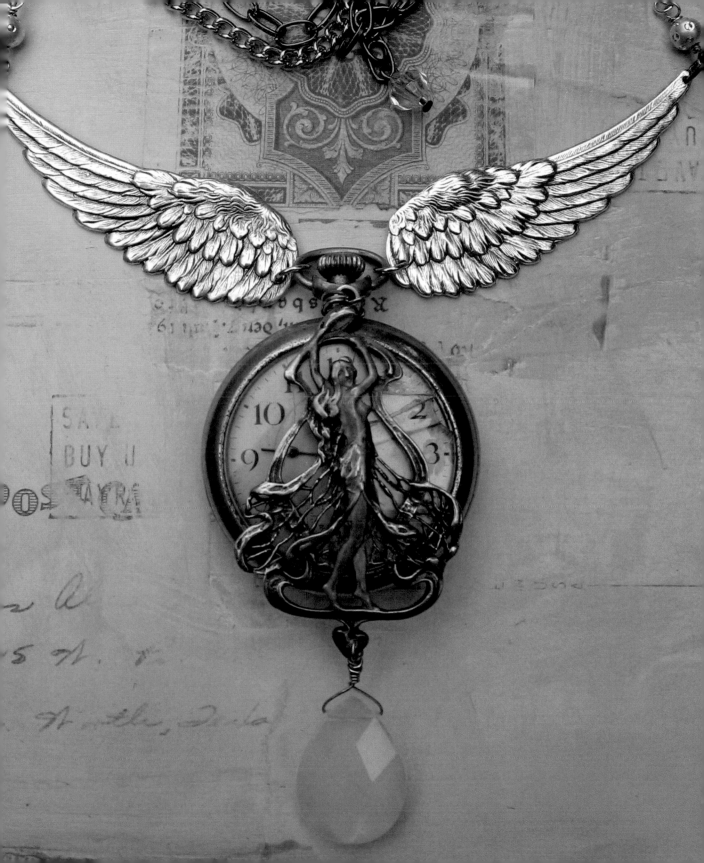

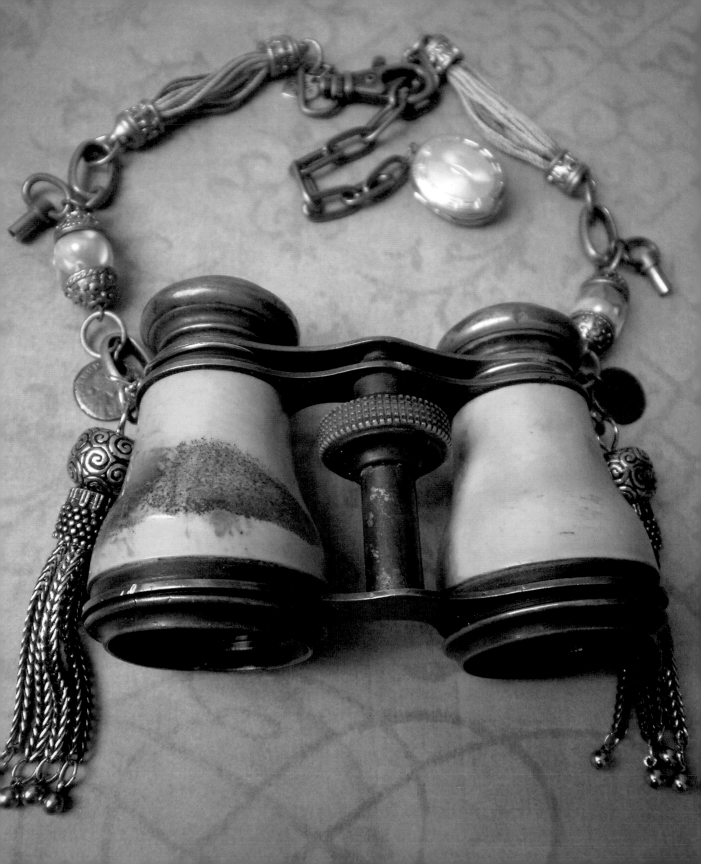

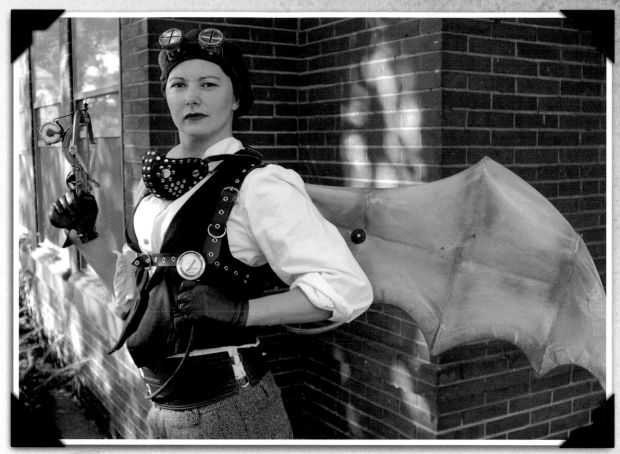

43

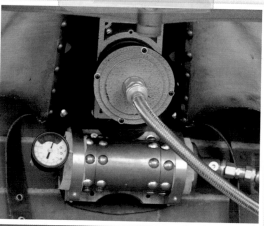

**Opposite** *Steampunk Adventurer's Club Necklace*, 2010, old binoculars, bolts, chains.

**This Page** *Steam Ornithopter*, *Leather Gas Mask*, and *Clockwork Arm Replacement Arm Mark II*, brass tubing, sheet brass, chrome sheet, various fittings, kydex, leather, found objects. Worn by Scrivener, these pieces were created in collaboration with Thomas Willeford. The raygun was made by Weta Workshops, New Zealand.

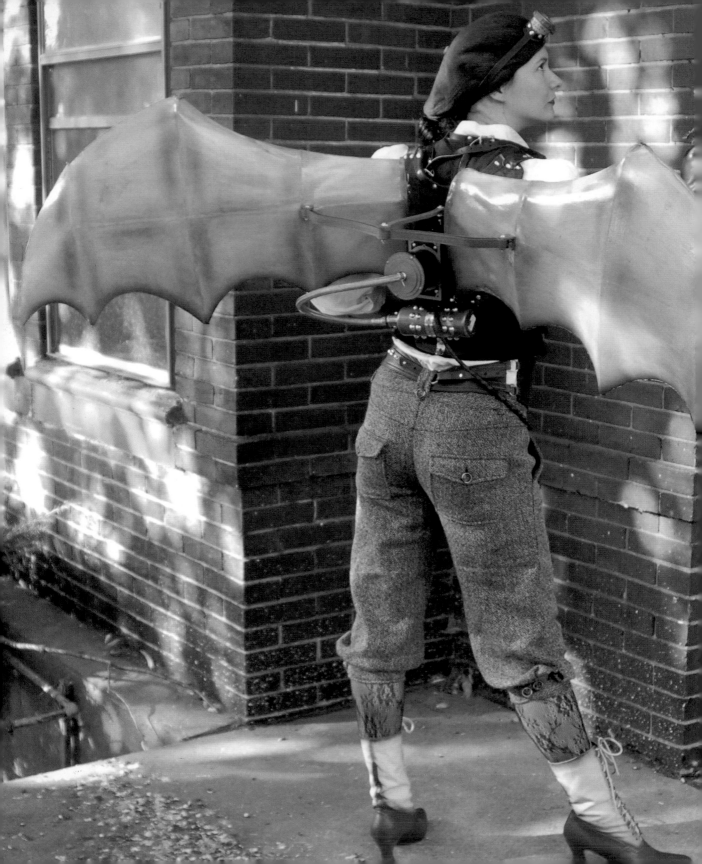

# Thomas Willeford

## LORD ARCHIBALD "FEATHERS" FEATHERSTONE
### Harrisburg, Pennsylvania, United States

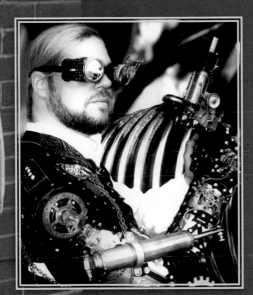

With degrees in physics, history, and art, it was perhaps inevitable that Thomas Willeford would be a Steampunk enthusiast. His work attempts to blur the precarious line between art and engineering. If upon viewing a piece one does not ask, "Does that actually work?" then Willeford considers the piece a failure.

Sculpture and wearable art are Willeford's preferred art forms because he cannot draw or paint very well. Willeford's alter ego, Lord Archibald "Feathers" Featherstone, and his partner, Amanda Scrivener (a.k.a. Professor Isadora Maelstromme), have been exhibiting their work throughout the United States and Europe for years. They hope to continue to support the cause of mad scientists everywhere for many more years to come.

Opposite Shown here is the *Steam Ornithopter*, designed and created by Thomas Willeford and Amanda Scrivener, and worn by Scrivener.

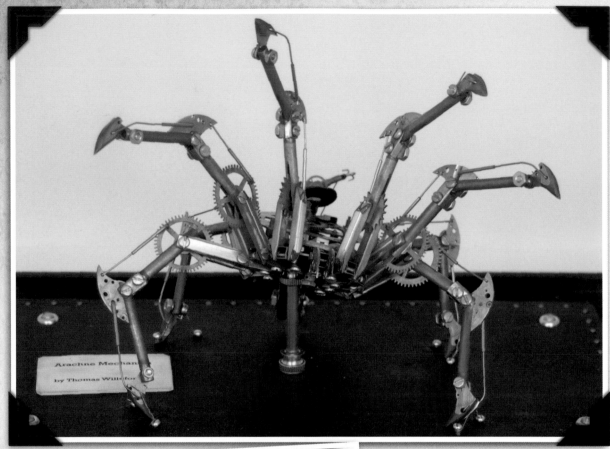

Arachne Mecha...
by Thomas Wille...

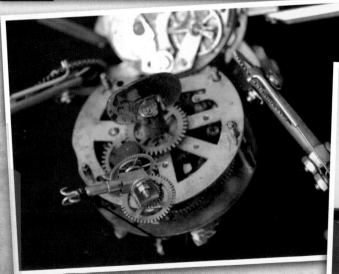

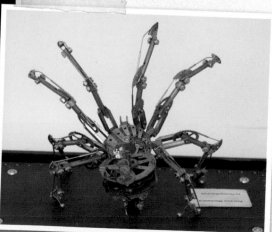

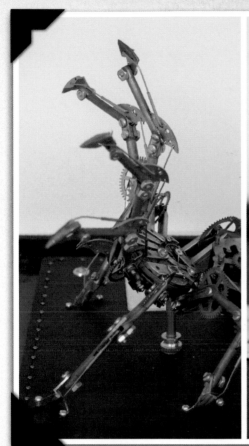

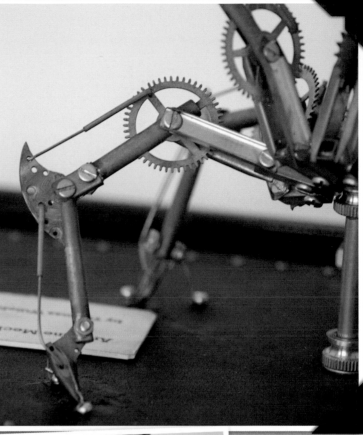

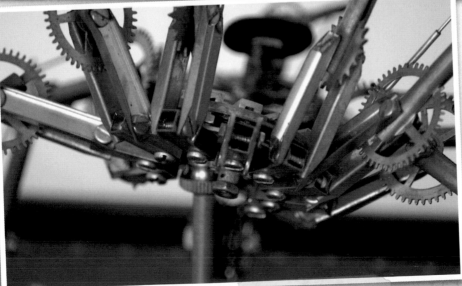

**Opposite** *Arachnia Mechanica*, brass. Thomas Willeford's brass spider is a fully articulated stop-motion animation model.

**This Page** Several angles of Willeford's *Arachnia Mechanica* show the details of its construction and movement.

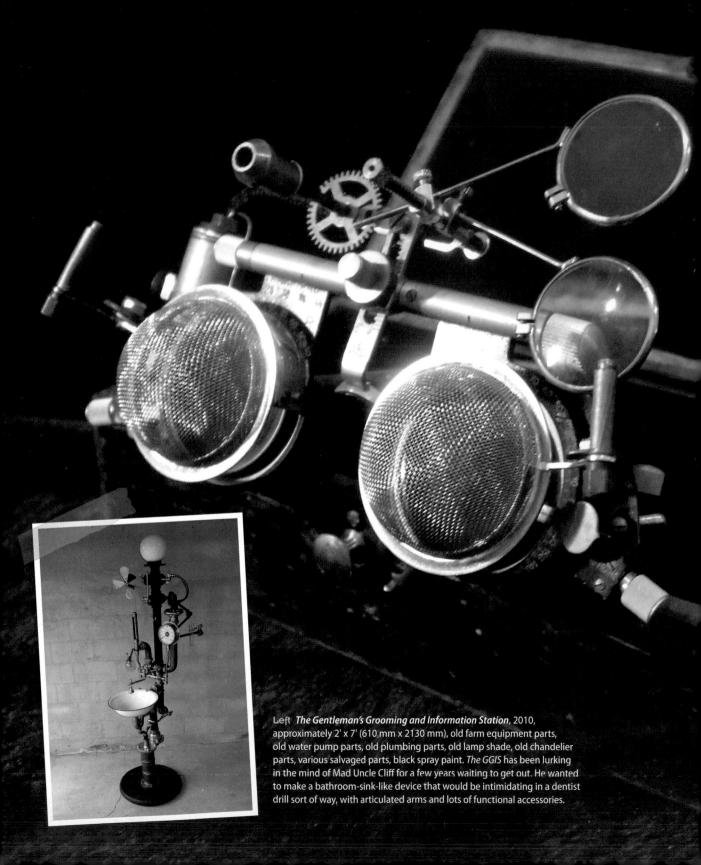

**Left** *The Gentleman's Grooming and Information Station*, 2010, approximately 2' x 7' (610 mm x 2130 mm), old farm equipment parts, old water pump parts, old plumbing parts, old lamp shade, old chandelier parts, various salvaged parts, black spray paint. *The GGIS* has been lurking in the mind of Mad Uncle Cliff for a few years waiting to get out. He wanted to make a bathroom-sink-like device that would be intimidating in a dentist drill sort of way, with articulated arms and lots of functional accessories.

# Cliff Overton

## MAD UNCLE CLIFF
### Bundoora, Victoria, Australia

Opposite *The Inspectacles*, 2009, an old pair of phoropters, magnifying lenses, tea strainers, LED light, old brass bits, shoe lace, colored lenses. Overton considers *The Inspectacles* to be part of his "rite of passage" into Steampunk tinkering, as most tinkerers make a pair of goggles at some stage. *The Inspectacles* were inspired by Johnny Depp's character in the film *Sleepy Hollow*.

For Cliff Overton, Steampunk art is many things: it's a rebellion against the beige and plastic look, it's an attempt to subvert design culture, it's ornamentation for the sake of ornamentation, it's recycling and putting the fun back into modern products, and it's romanticism.

Overton begins any modification by looking at a modern product and trying to decide what it would look like if it were running on steam, and wheels and pistons were part of its operational design. There would be pressure gauges, valves, and switches. Overton takes these elements from the past and uses them to subvert the smooth shapeless panels of today's technology.

Creations by Overton, in his Steampunk persona Mad Uncle Cliff, rebel against his ten years of industrial design experience. He knows that a project is good if someone tells him no one else will ever want it. Overton then knows his creation is a success because he did not make it for someone else, he made it for himself.

Overton is a firm believer that a new market for robustness, reliability, and usability will soon come to the forefront of today's society—just the place for Steampunk art and design.

For more information about Overton and his designs, please visit his blog at *http://austeampunk.blogspot.com*, or email him at *cliffo@three.com.au*.

49

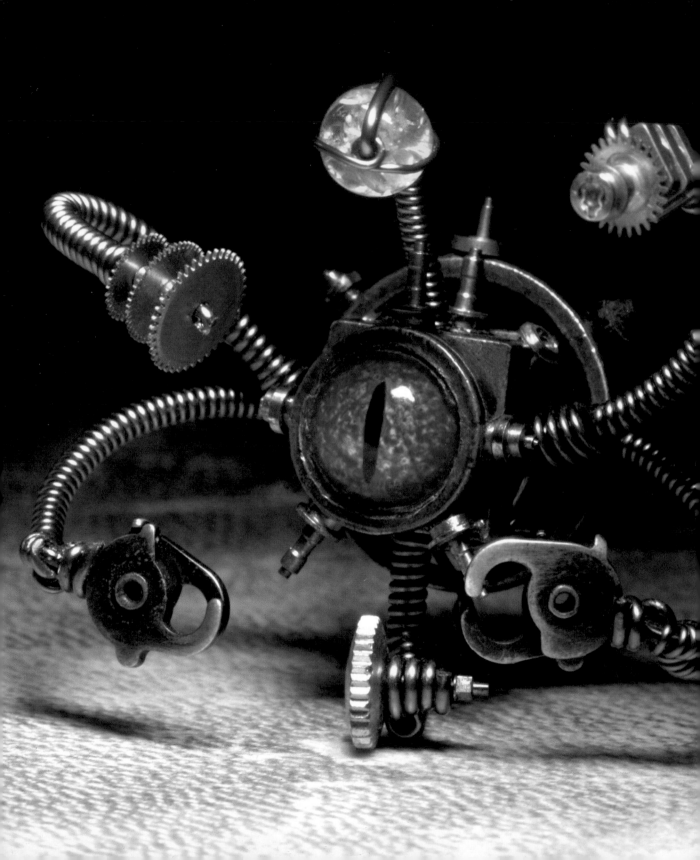

# Daniel Proulx

## Montreal, Quebec, Canada

Daniel Proulx was born in Montreal and spent a considerable amount of time traveling the world before returning to his artistic roots, becoming an independent artist in 2008. He has found great inspiration in the steam era and now makes Steampunk jewelry with metal wire, gemstones, vintage clock parts, and other unusual components. He loves creating organic shapes from wire and making intricate designs with a mechanical/industrial feel.

When Proulx was young, he used to daydream about fantastic imaginary worlds. He would draw monsters, invent stories about magical items, or role-play with friends. Now Proulx brings his art to life with stories from a distant parallel Steampunk universe. He uses his creations to share his passion for the world of Steampunk with the rest of us.

Opposite *Beholder Robot Sculpture*, 2009, copper, clock parts, taxidermy glass eye, metal beads, findings.

51

Sunday, October 13, 1809 • Quebec, Canada

# The Montreal Science Journal

By Daniel Proulx

This morning, around three o'clock, a large explosion flattened three buildings in the heart of the industrial district. The explosion originated from the laboratory of a controversial scientist. No remains were found. The blast was so powerful that the scientist was instantly pulverized.

Although the cause of the explosion has not yet been confirmed, experts have reason to believe that it might be related to a mysterious device found in the center of the crater produced by the blast.

Earlier this year, the scientist failed, for the third time, to successfully demonstrate his so-called time machine at the Academy of Universal Scientific Wonders (AUSW). It would appear that this time his experiment went too far.

A few mysterious items were found among the ruins of the laboratory. They will be displayed at the local museum for a brief period of time before being sold to the highest bidder at an auction whose proceeds will benefit the AUSW.

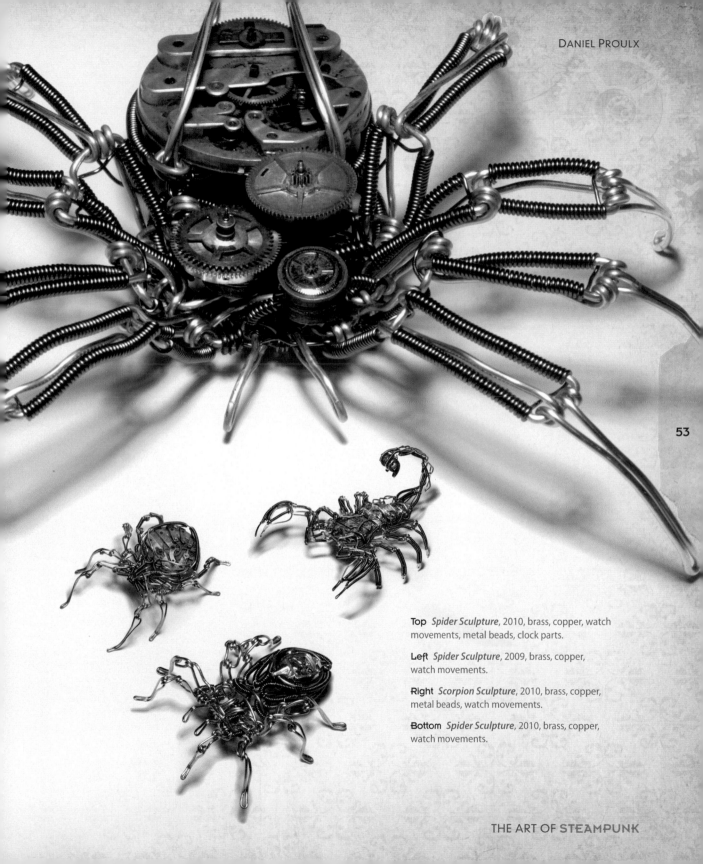

**Top** *Spider Sculpture*, 2010, brass, copper, watch movements, metal beads, clock parts.

**Left** *Spider Sculpture*, 2009, brass, copper, watch movements.

**Right** *Scorpion Sculpture*, 2010, brass, copper, metal beads, watch movements.

**Bottom** *Spider Sculpture*, 2010, brass, copper, watch movements.

THE ART OF STEAMPUNK

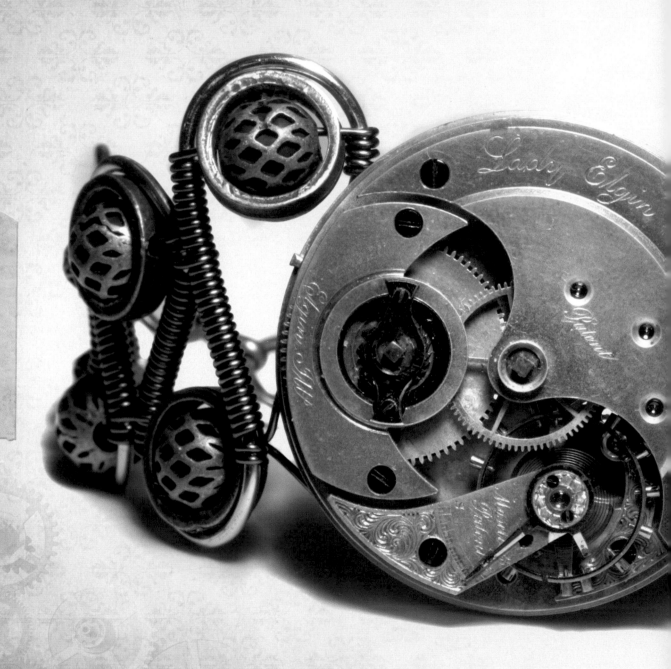

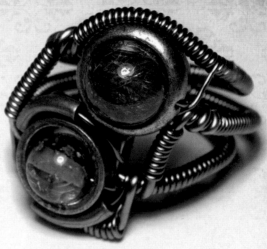

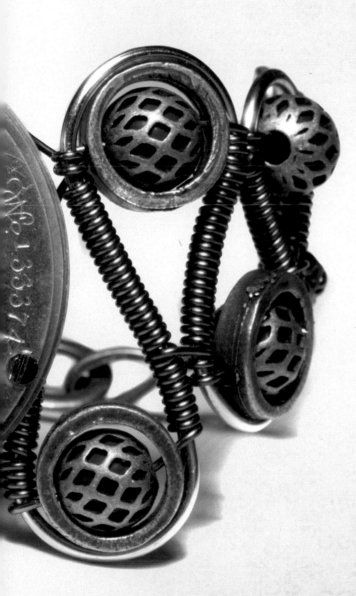

**Opposite** *Lady Elgin Brass Watch Movement Bracelet*, 2010, brass, metal beads, watch movements, findings.

**Above** *Green Amber and Copper Rutilated Quartz Ring*, 2010, copper, clock parts, amber, quartz, metal beads.

**Right** *Tie Tack With Reptile Eye*, 2010, clock parts, taxidermy glass eye, metal beads.

**Below** *Railroad Antique Brass Watch Movement Bracelet*, 2010, brass, copper, metal beads, watch movements, findings.

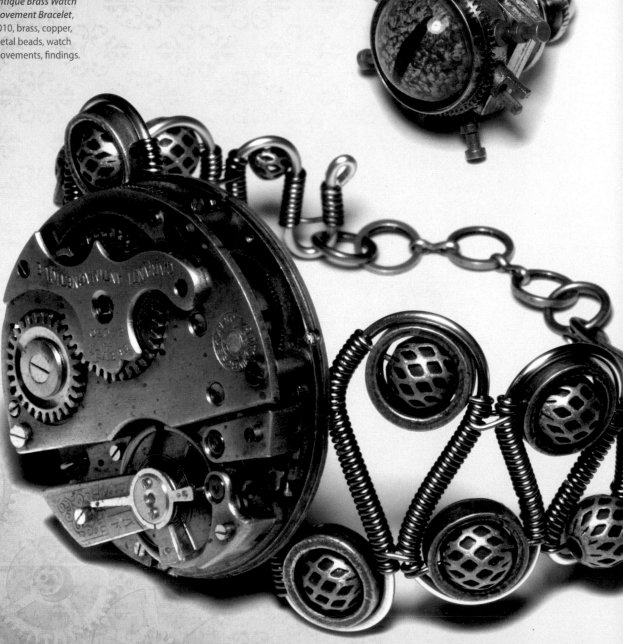

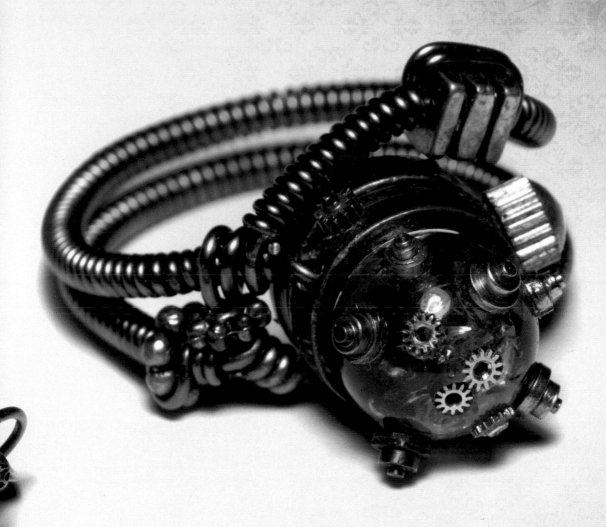

**Above** *Asymmetric Ring With Clock Parts Inlaid In Amber*, 2009, copper, clock parts, amber, metal beads.

# Eric Freitas

## Royal Oak, Michigan, United States

Photo by Sarah Freitas

Opposite This photo shows the details of *Quartz 6*, a creation that was completed by Freitas in 2008.

Eric Freitas is a clockmaker with an art degree. He hand machines and sculpts every gear and chain link of his clocks to create his bizarre and beautiful timepieces. It's unlikely that many artists would tackle the kind of learning curve that clock-making presents, but Freitas is dedicated, driven, and very passionate about making his ideas become living ticking realities.

In 1999, Freitas graduated from the Center for Creative Studies with a major in graphic design and illustration. He never committed to the commercial world as planned and instead directed his attention to a far less common art form: clock making. Prior to this change in artistic direction, Freitas had never used machining tools. He studied from clock making and machining books for the sole purpose of executing his ideas.

With every project, Freitas tests the boundaries of horology to make way for a style never seen in this very traditional world. He never allows the mechanical parts to dictate what his finished projects will look like. The mechanical is always structured around the visual rather than the other way around. After countless hours of precise work, the immediacy and essence of Freitas' initial sketch is still prevalent when the finished work makes its first tick.

Freitas documents the progress of his clocks on his website, *ericfreitas.com*, including *No. 7*, Freitas' largest clock creation.

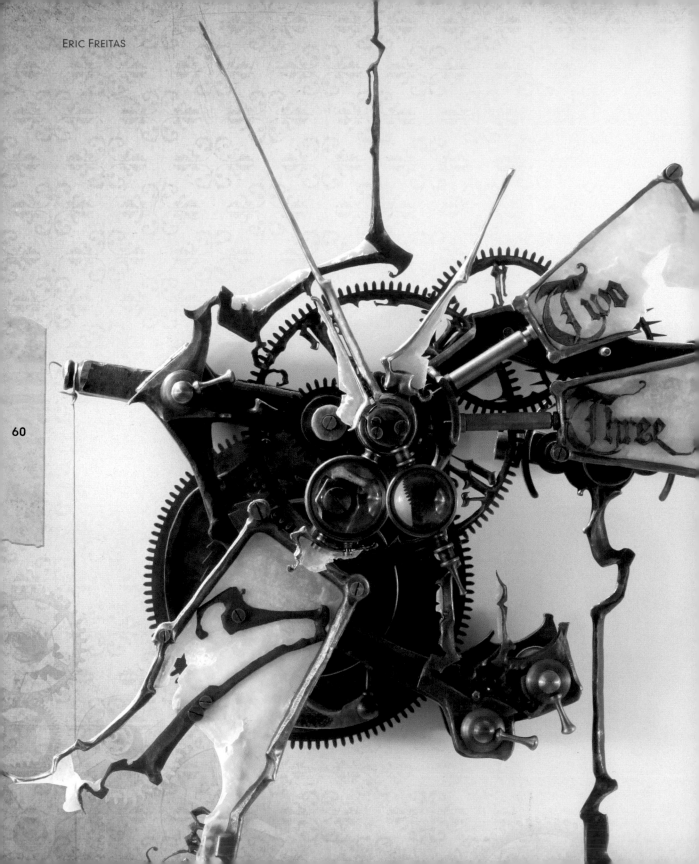

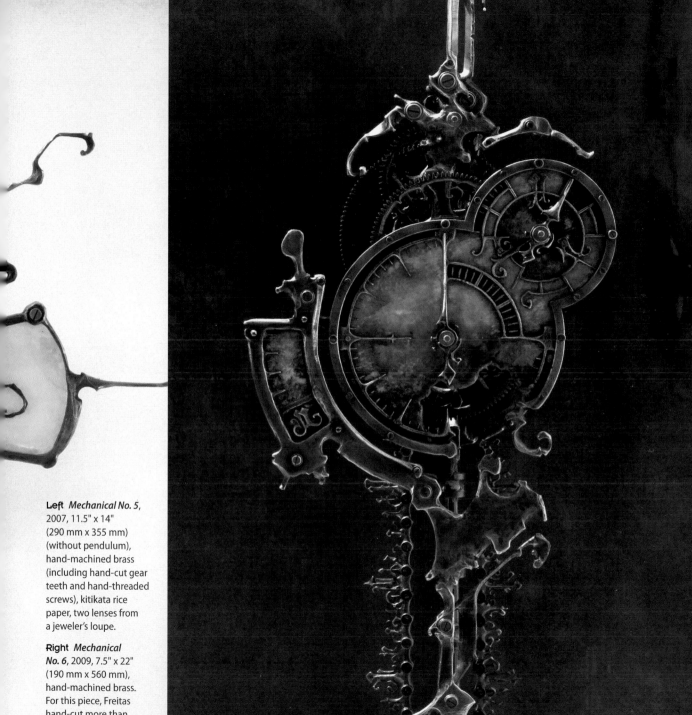

**Left** *Mechanical No. 5*, 2007, 11.5" x 14" (290 mm x 355 mm) (without pendulum), hand-machined brass (including hand-cut gear teeth and hand-threaded screws), kitikata rice paper, two lenses from a jeweler's loupe.

**Right** *Mechanical No. 6*, 2009, 7.5" x 22" (190 mm x 560 mm), hand-machined brass. For this piece, Freitas hand-cut more than 1,000 links to form the 10 foot chain and hand-threaded more than 100 screws.

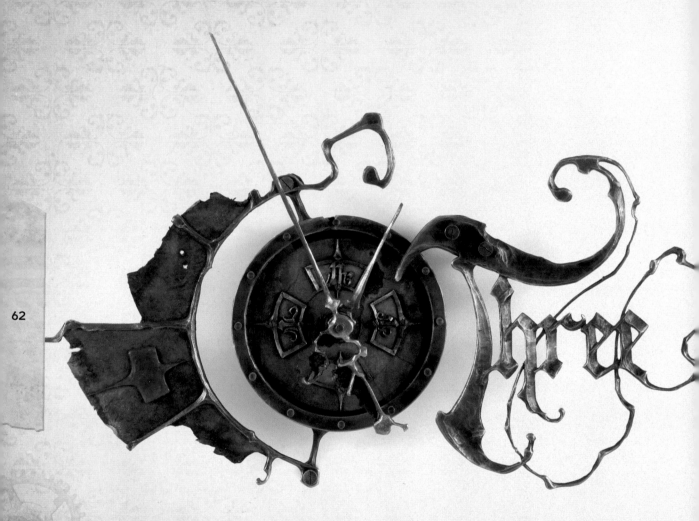

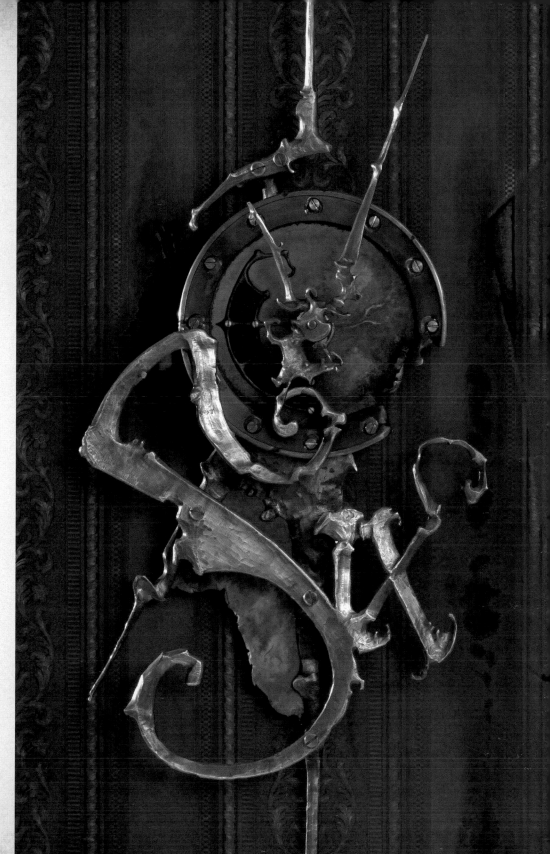

**Left** *Quartz 6*, 2008,
16.5" x 7" (420 mm x
180 mm), hand-machined
brass held together with
hand-threaded screws,
with painted, weathered,
and aged paper.

**Right** *Quartz 9,* 2009,
7" x 12" (180 mm x
305 mm), hand-machined
brass held together by
hand-threaded screws,
with painted, weathered,
and aged paper.

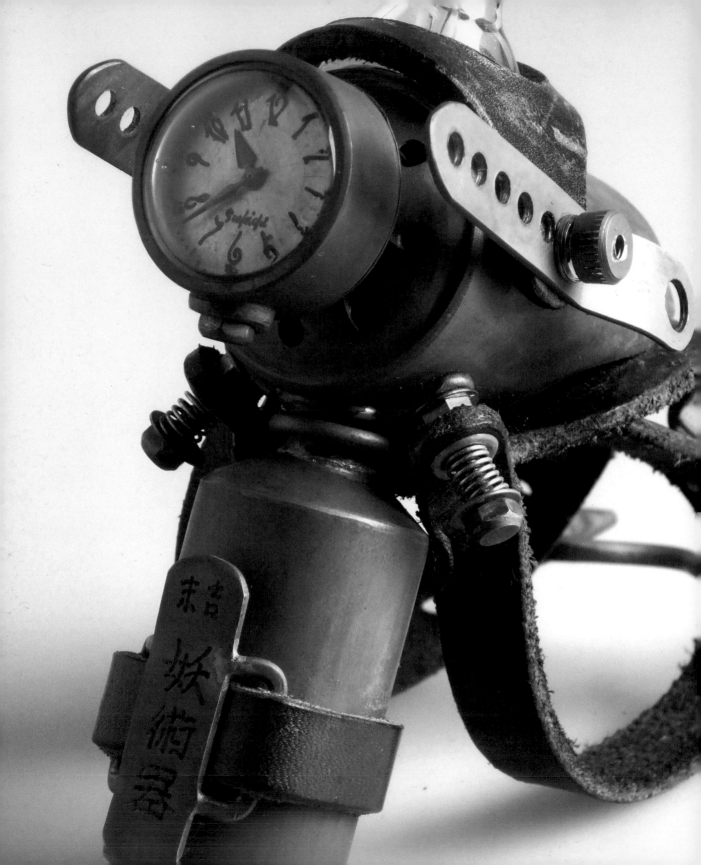

# Haruo Suekichi

**Tokyo, Japan**

Photo by Ikumi Mochida

Opposite **Magical & Mystic Watch**, 2003, 4" x 4" x 2.5" (100 mm x 100 mm x 60 mm), brass, leather, springs. Wave your hand while wearing this watch, and it will make a fun sound.

Haruo Suekichi was born on May 15, 1970, and considers himself to be a regular guy who just happens to have a passionate "thing" for watches.

When Suekichi first started making watches in his mid-twenties, it was only as a hobby. At the age of twenty-four, he started selling his handmade watches on the street, in parks, and at small flea markets in Tokyo. He was soon discovered by a merchant from a small goods store who adored his watches. By the time he turned twenty-nine, Suekichi was using the merchant's shop cellar as his own workplace.

Although Suekichi did not advertise his work and only attended a few small exhibitions, the media soon began to notice him.

Over the next ten years, Suekichi, who had never studied art and who had only started making watches for fun, grew to become a world-renowned Steampunk watch creator.

Suekichi's watches have been featured in print magazines such as *Time*, *Chief*, *PingMag, Tech Crunch Magazine* (Japan), and *A Day* (Thailand). His work has also appeared on numerous art and design websites.

The Oxford Steampunk exhibition was the first time Suekichi displayed his watches for a large international audience.

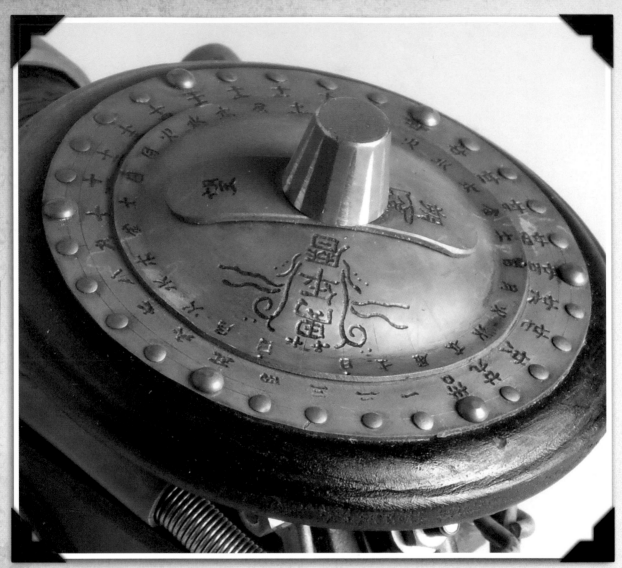

*Lunar Period*, 2007, 2.75" x 3" x 3.5" (70 mm x 80 mm
x 90 mm), brass, leather, wood. If you like astrology,
you'll love this piece. It tells you the stages of the
moon, which can help you make big decisions about
relationships, money, and your career.

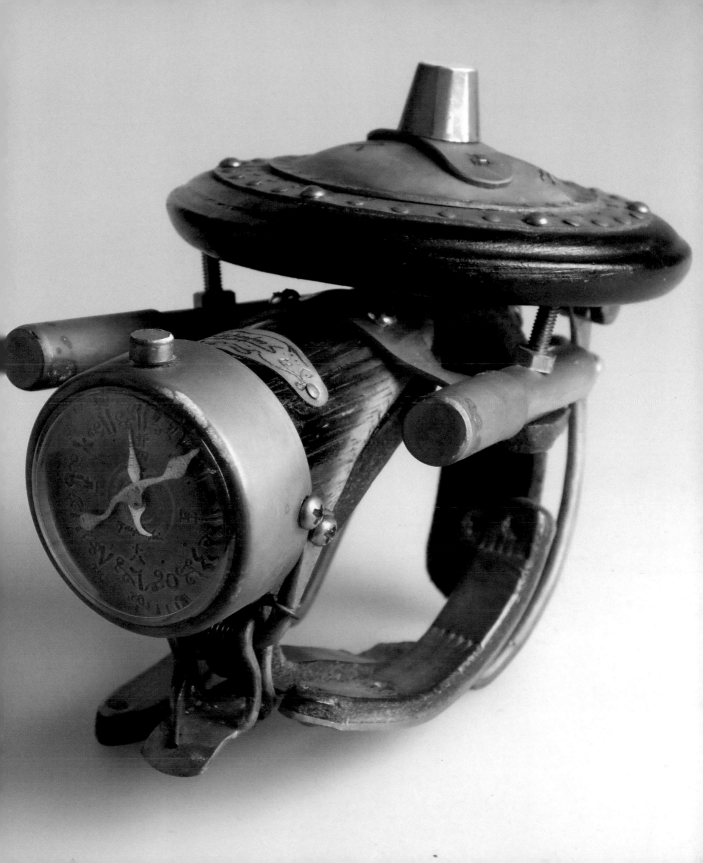

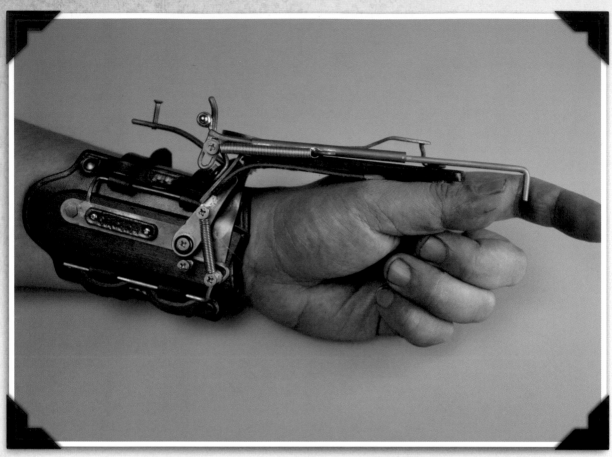

68

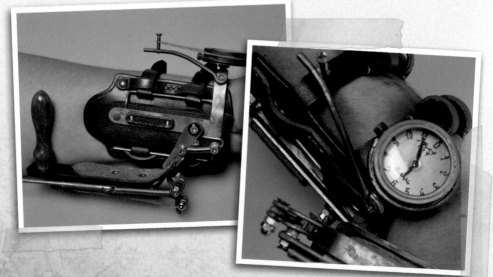

**This Page** *Rubber Band Gun*, 2010, 6" x 4" x 3" (160 mm x 110 mm x 80 mm), brass, leather, springs. Combining the functional and fun, this piece is both a watch and a toy.

**Opposite** *Energy Drink*, 2000, 6" x 3.5" x 3.5" (160 mm x 90 mm x 90 mm), brass, leather. This piece will hold a bottled or canned drink and can be worn around the waist on a belt.

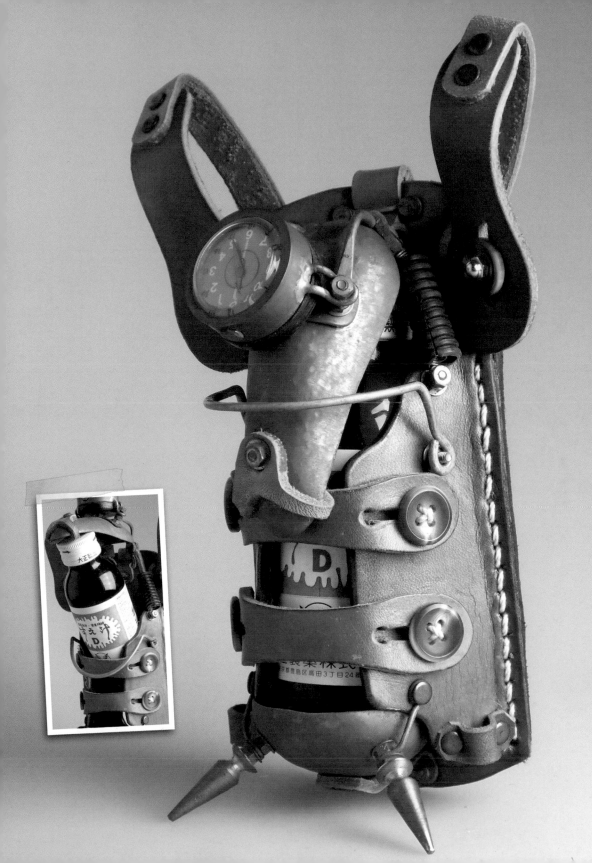

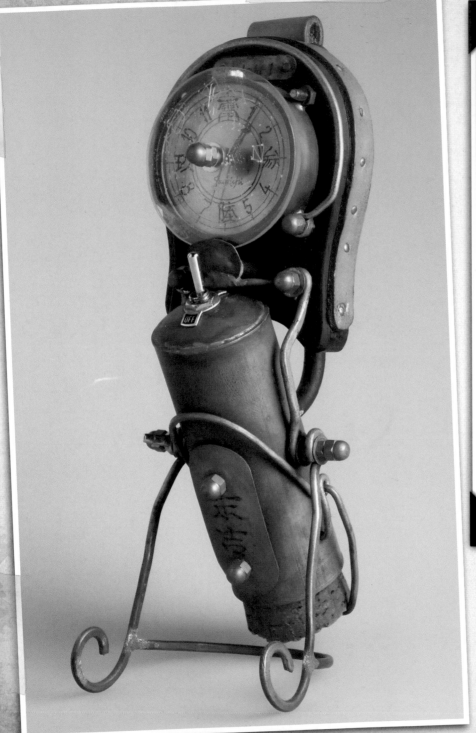

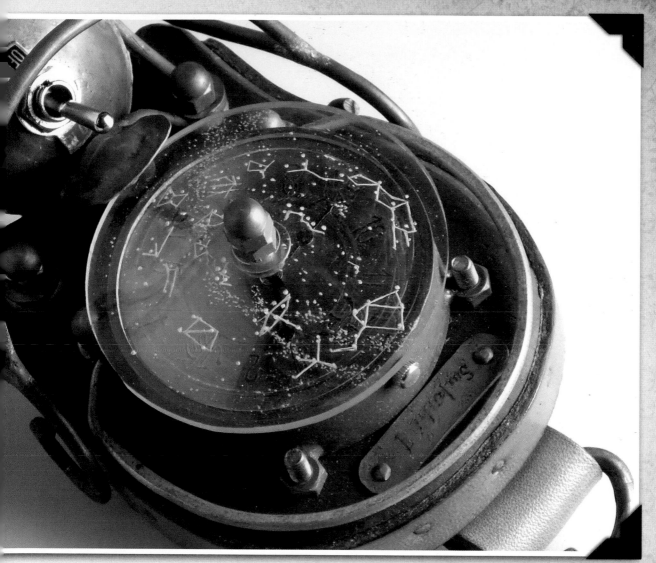

***Star Watching-Galileo***, 2008, 2" x 3" x 2" (50 mm x 80 mm x 50 mm), brass, leather. Suekichi's creation acts as a small planetarium, tracking the movements of the planets and stars. It can also be worn around the waist on a belt.

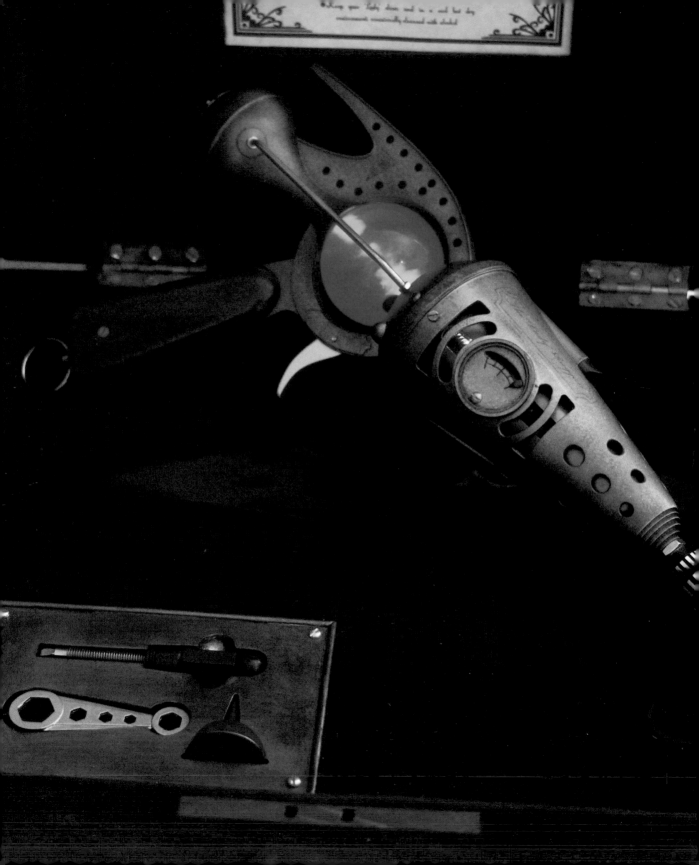

# Ian Crichton

## HERR DÖKTOR
### Woking, Surrey, United Kingdom

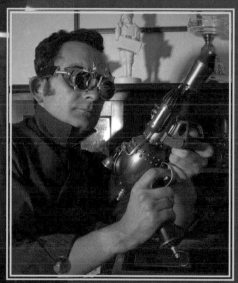

Opposite
*The Lady Raygun*, 2010,
12" x 14" x 5" (350 mm
x 355 mm x 130 mm),
brass, wood, velvet,
acrylic, steel, aluminum.
*The Lady Raygun* was a
commissioned piece
that includes machined
aluminum and brass
accessories, with an
illuminated interior and
glowing power sphere.

From his secret laboratory in the Home Countries, Ian Crichton, a.k.a. Herr Döktor, attempts to recreate the modern world as it should have been—in riveted brass, burnished copper, polished leather, and blown glass.

Crichton is a freelance prop and model maker whose commercial work includes action figures from *The Simpsons* and *Doctor Who*, along with a range of props and vehicles from the worlds of Gerry Anderson. Examples of his work for museums and exhibitions can be found around the globe.

Crichton's interest in Steampunk style comes from his love of history and speculative science fiction—the worlds of Verne and Wells, the engineering of Brunel, and the displays of The Great Exhibition.

He hopes you will enjoy his creations as much as he enjoys producing them.

73

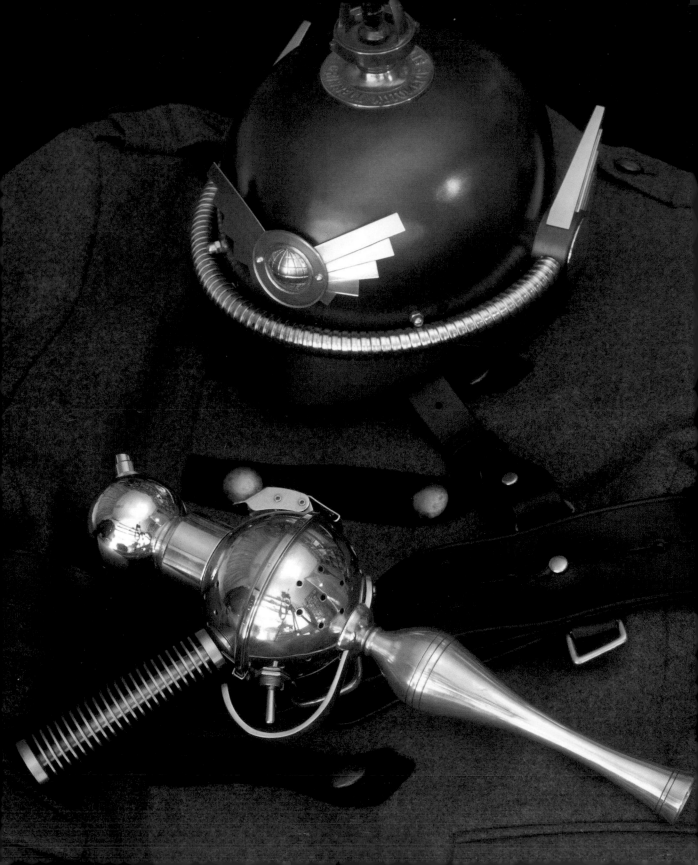

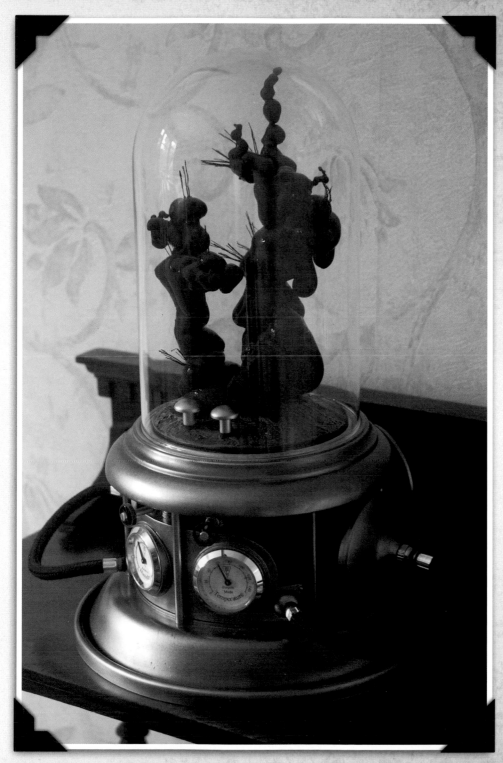

**Opposite** *Airship Commander Helm* and *Help the Aged Pistol*, 2009, Helmet: 10" x 9" x 9" (255 mm x 230 mm x 230 mm),, glass fibre composite, steel, brass, found objects. Pistol: 13" x 8" x 3.5" (330 mm x 200 mm x 90 mm), repurposed found metal objects. Herr Döctor's helmet has a built-in fire extinguisher, a must onboard a hydrogen airship. His *Help the Aged Pistol* uses a pulsed electromagnetic burst from a coiled array to "punch" an assailant to the ground, minimizing the risk of fire.

**Left** *The Red Weed: Cruentus Ervum Stella Martis Vulgaris*, 2009, 20" x 8" x 8" (500 mm x 200 mm x 200 mm), brass, glass, polyurethane. The *Red Weed* is a combined display and filtration unit with motorized filter bellows. The machine is used to hold a surviving specimen of the common Martian Red Weed acquired from the common land of Surrey.

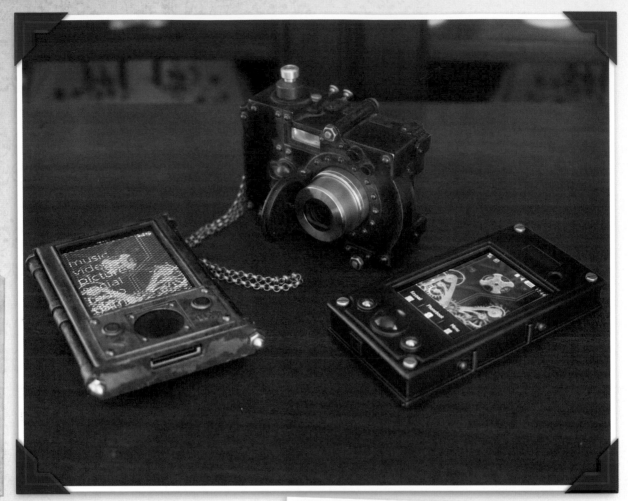

76

This Page  *Impedimentia: Electrocomnicon*,
*Electro Iconograph*, and *Electrotelecomnicom*,
2009–2010, approximately 2" x 1" x 5" (50 mm x
250 mm x 130 mm), brass, various synthetics. Shown
here are slide-on protective cases containing an
mp3 player, mobile telephone, and digital camera.

Opposite  *Celestial Sphere "Britannia,"* 2009,
17" x 17" x 17" (430 mm x 430 mm x 430 mm), brass,
acrylic, steel, various synthetics. This is a shipyard-style
model of a vessel built to traverse the Aether between
worlds with its own launch cradle and loading engine.

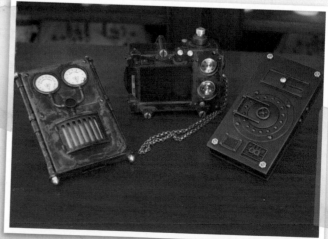

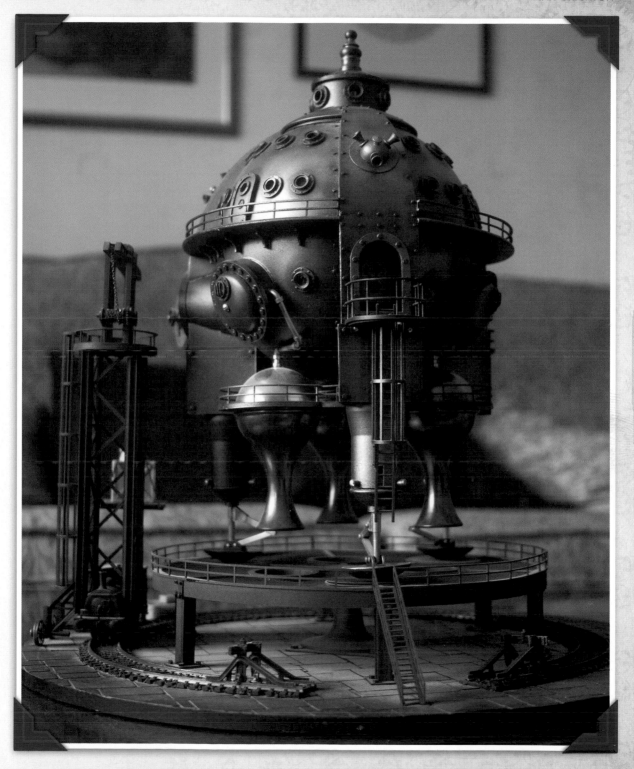

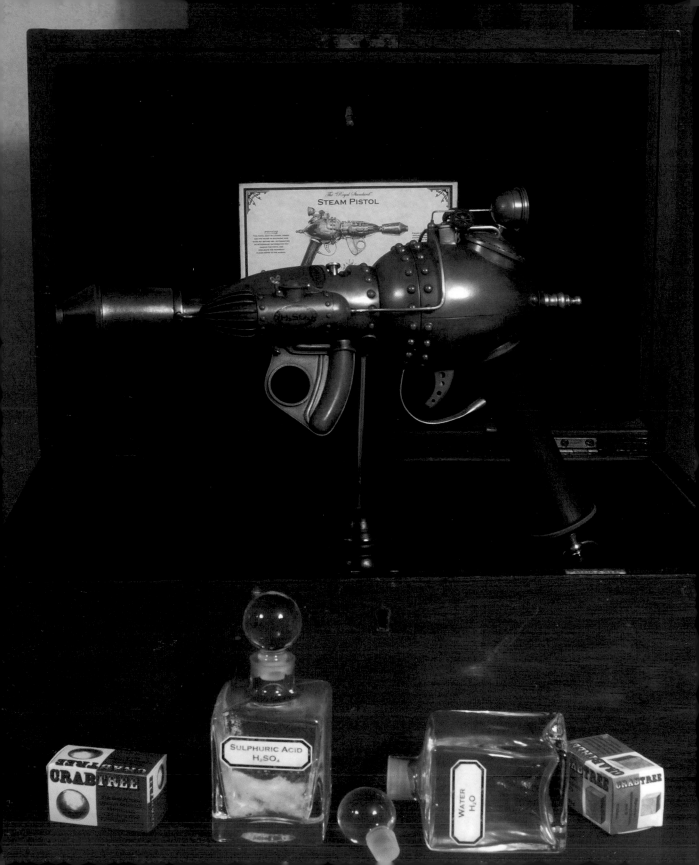

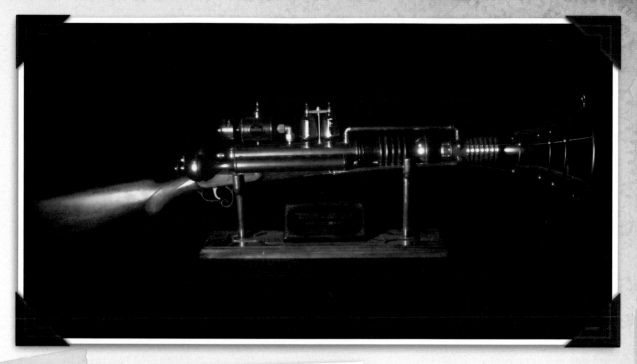

**Opposite** *Steam Pistol*, 2009, 12" x 18" x 6" (305 mm x 460 mm x 150 mm), acrylic, brass, steel, wood, velvet. Herr Döctor's *Steam Pistol* can propel a projectile at high speed using the steam produced from the desiccation of water. Two styles of projectile may be selected from the two magazines: spherical for your Earthly adversaries, and cubed for your un-Earthly opponents. The case for the pistol is a hardwood cutlery case from the royal company Mappin & Webb.

**This Page** *The Thunderbuss: A Gentleman's Sonic Hunting Rifle*, 2009, 41" x 12" x 7" (1040 mm x 305 mm x 180 mm), wood, brass, copper, steel, various synthetics. This piece was produced over the winter of 2008-2009 and contains working settings gauges labeled "Quiet, Loud, Louder, Pardon?" and "Wound, Hurt, Kill, Liquefy."

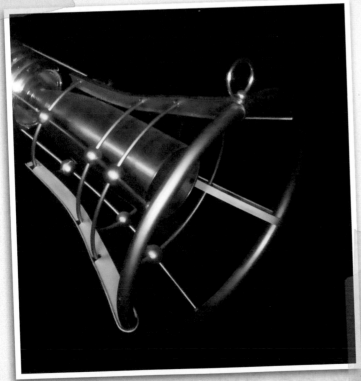

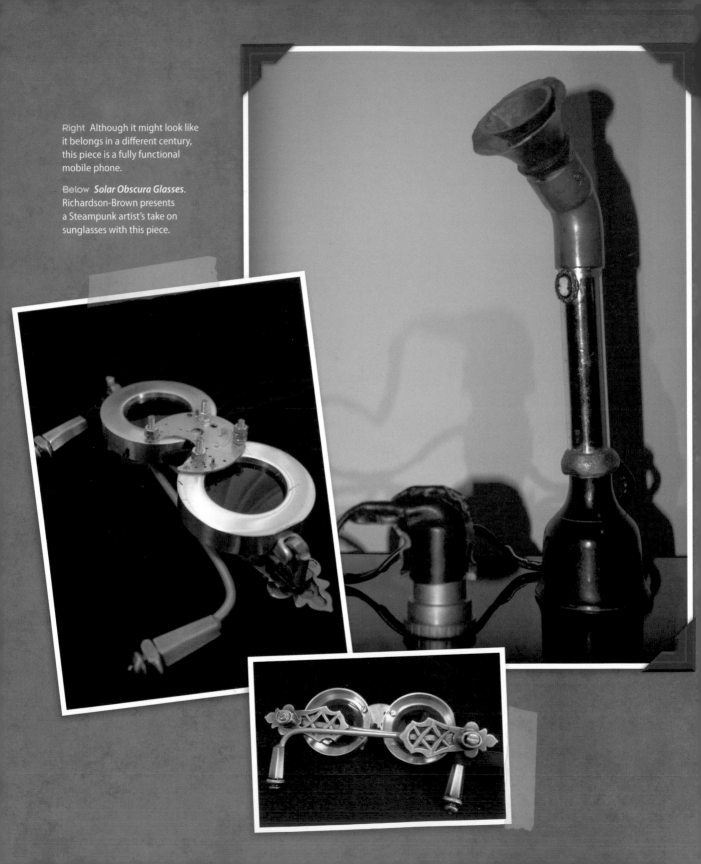

Right  Although it might look like it belongs in a different century, this piece is a fully functional mobile phone.

Below  *Solar Obscura Glasses*. Richardson-Brown presents a Steampunk artist's take on sunglasses with this piece.

# James Richardson-Brown

## CAPTAIN SYDEIAN
### Southampton, Hampshire, United Kingdom

Photo by Ian Horner

Born in London in 1982, James Richardson-Brown showed no early interest in art of any kind, focusing his attention on scientific endeavors instead. It was Richardson-Brown's father, a draughtsman, who introduced him not only to science fiction literature, but also to the many links between art and science.

After an education focusing on scientific disciplines, Richardson-Brown began to pursue a career in information technology. As a hobby, he took up writing and creating visual 3-D art in a style that was then known to very few: Steampunk.

In 2007, Richardson-Brown started the UK's first Steampunk "meet-up," intending to create awareness of the style. This early event drew a crowd of three people. During the next two years, however, the event also began to grow. Recently, attendance hit one hundred people.

Since starting his artistic career, Richardson-Brown has published one book, *The Sydeian Coalition—A Steampunk Adventure* (co-written with Paul Taylor), and two articles. He has also had his 3-D visual art featured in various magazines and websites. As time goes on, Richardson-Brown is planning to find a publisher for his writing and to continue to create 3-D visual art to entertain and enthrall.

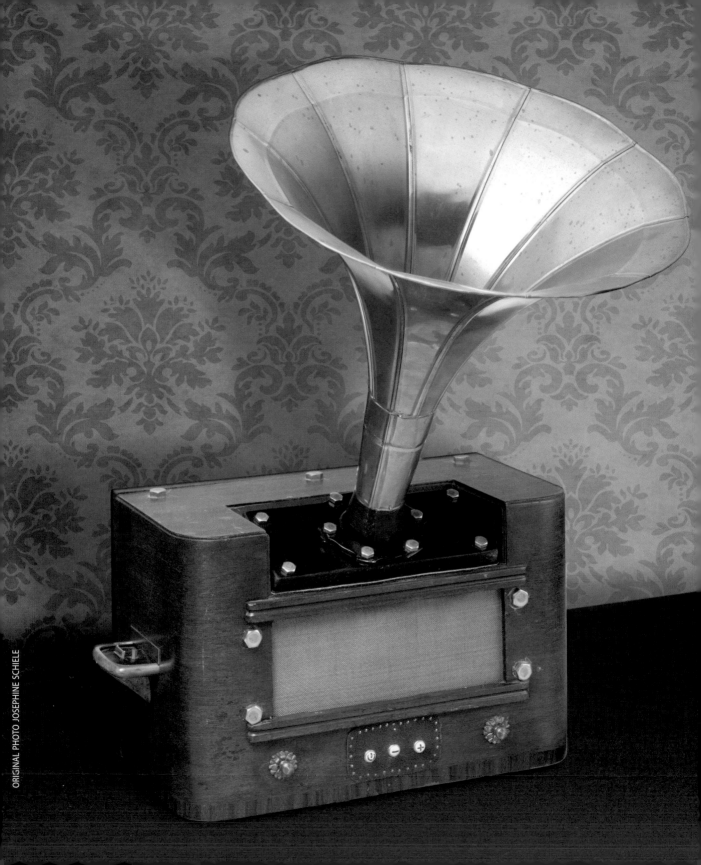

# Jesse Newhouse

### New York, New York, United States

Photo by Gregg Delman

Opposite
*Gramophonobox MKII*, 2008, Sony sound dock and iHome parts, old radio parts, brass bolts, brass phonograph horn. The *Gramophonobox* is an iPod dock that produces the same sound quality as the most modern of speaker systems. Newhouse only builds iPod docks because he enjoys the ironic juxtaposition of the sleek modern iPod (the antithesis of Steampunk) and his elegant handcrafted housings.

Jesse Newhouse was born in Manhattan under a full moon on Friday the thirteenth in 1976. In 1994, he went to the University of Colorado in Boulder and studied math before returning to New York. He briefly studied film at The New School, then left for Los Angeles in 2001. There, he worked his way up through the ranks of film production. Today Newhouse is back in New York City producing films for the SyFy channel under Paradox Pictures, along with his long-time business partner, Brandon Hogan.

Newhouse's love of Steampunk began with the *Myst* video game series, created by Robyn and Rand Miller in 1991. Since then, Steampunk has grown to be a passion. Newhouse has always loved model building and working with his hands. He never dreamt of being an artist, but is committed to doing his part for the Steampunk movement.

Newhouse has one sister, two very supportive parents, a loving wife, and a beautiful baby girl, who recently turned six months old.

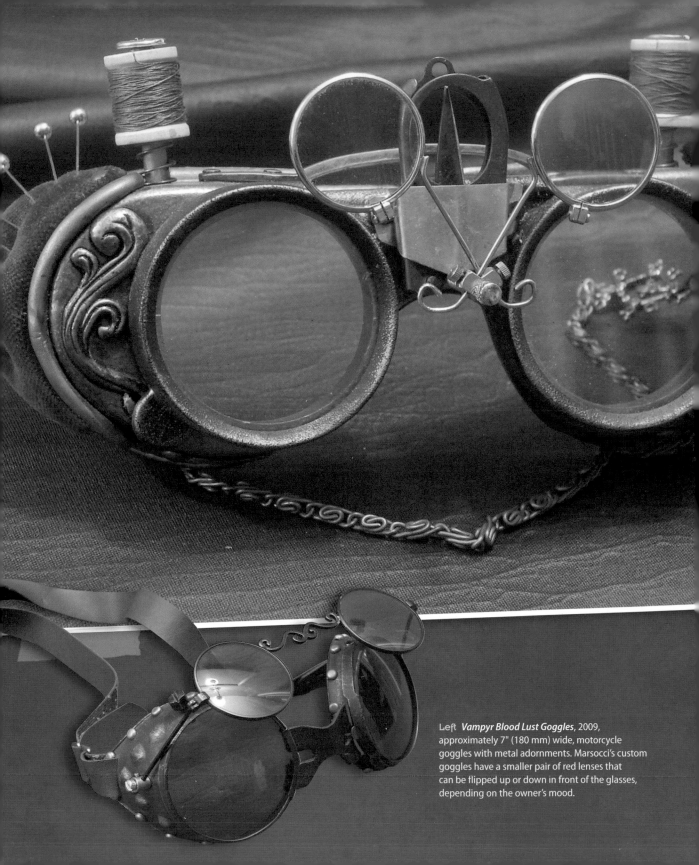

Left **Vampyr Blood Lust Goggles**, 2009, approximately 7" (180 mm) wide, motorcycle goggles with metal adornments. Marsocci's custom goggles have a smaller pair of red lenses that can be flipped up or down in front of the glasses, depending on the owner's mood.

# Joey Marsocci

## DR. GRYMM
### Hartford, Connecticut, United States

Photo by Ajar Communications

Opposite
*The Whole 9 Yards Goggles*, 2008, approximately 8" (200 mm) wide, welding goggles, various pieces of sewing equipment. These custom-made goggles hold pin cushions, a pair of folding scissors, interchangeable bobbins, pins, and magnifiers.

Joey Marsocci, a.k.a. Dr. Grymm, graduated from California Institute of the Arts with a BFA in Film and Animation and has been a freelance designer of theme park attractions, toys, puppets, graphic marketing products, film props, and private consignments for more than eighteen years.

Marsocci's company, Dr. Grymm Laboratories, currently provides custom designs of props and creatures for film production companies across the United States. Marsocci's custom contraptions and sculptures, such as his world-famous Steampunk "Eye-Pod" Victrola have been seen in Steampunk exhibits and publications around the world, including the Steampunk Exhibit held at Oxford University's Museum of the History of Science in 2009–2010.

In the summer of 2009, Marsocci hosted and curated the first annual Steampunk Bizarre in Middletown, Connecticut. The event was so popular that the Third Annual Steampunk Bizarre will be held at the Mark Twain House Museum in Hartford, Connecticut, in October 2011.

Marsocci has two books scheduled for publication in 2011: *1000: A Steampunk Collection* and *How to Draw Steampunk*.

For more information about Marsocci and his Steampunk art, please visit *www.DrGrymmLaboratories.net*, *www.DrGrymmLaboratories.com*, and *http://steampunkbizarre2010.blogspot.com*.

85

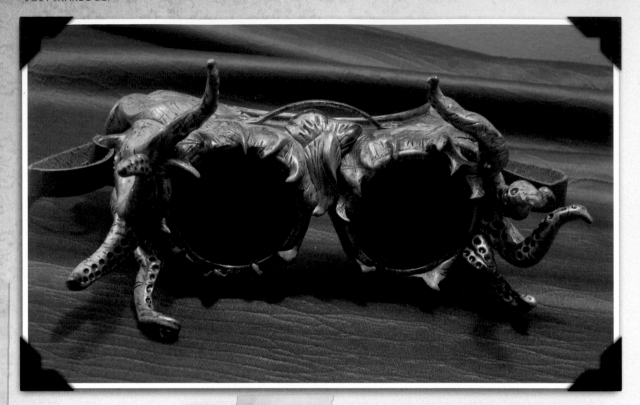

**Above**
*Squid Attack Goggles*, 2009, approximately 8" (200 mm) wide, hand-sculpted with epoxy. These tentacled glasses were inspired by Jules Verne's *20,000 Leagues Under the Sea*, and are a partner to Dr. Grymm's *Nautilus Goggles*.

**Right**
*The Nautilus Goggles*, 2009, approximately 8" (200 mm) wide, hand-sculpted with epoxy. These goggles are meant to be paired with the *Squid Attack Goggles*.

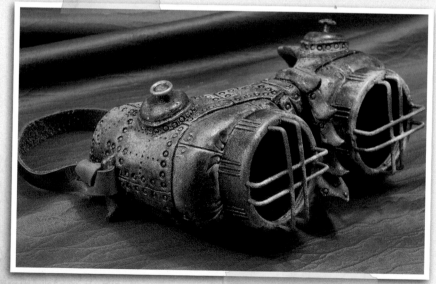

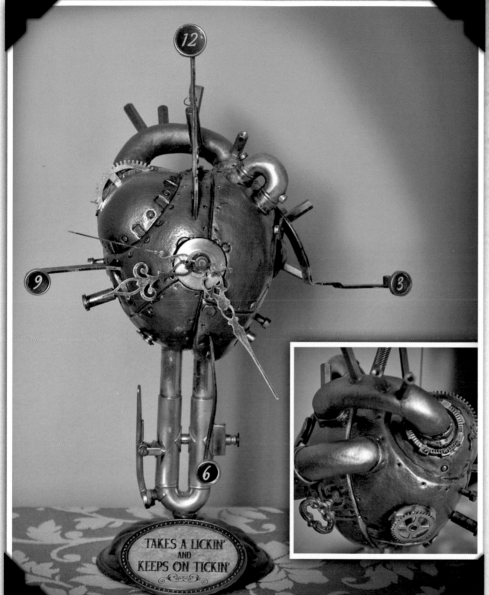

**Left** *Dr. Grymm's Clockwork Heart*, 2008, approximately 14" (355 mm) tall, found materials. Dr. Grymm created this piece in the memory of Allan DeBlasio. It was first displayed at the Steampunk Bizarre Exhibit in Connecticut.

**This Page**
*Victrola Eye-Pod*, 2008, approximately 9" (230 mm) tall, sculpture, found materials. This unique machine is a modded iPod Nano with a docking station that contains a USB charger. The iPod's menu is controlled by the pressure plate on the eye Dr. Grymm has added.

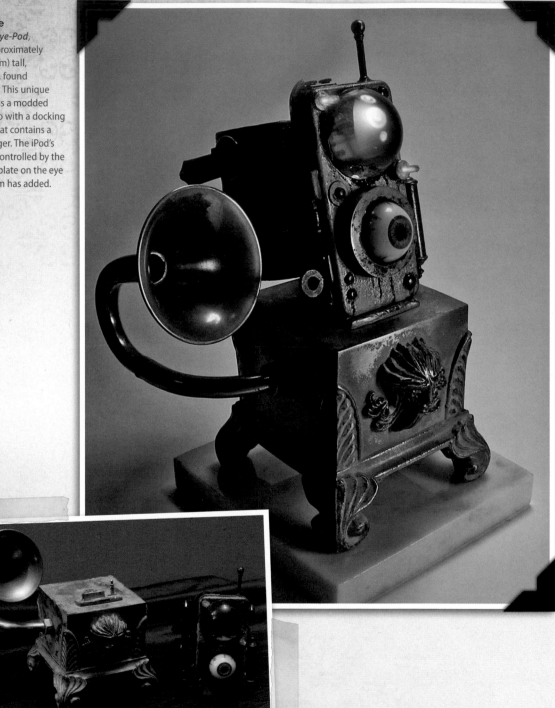

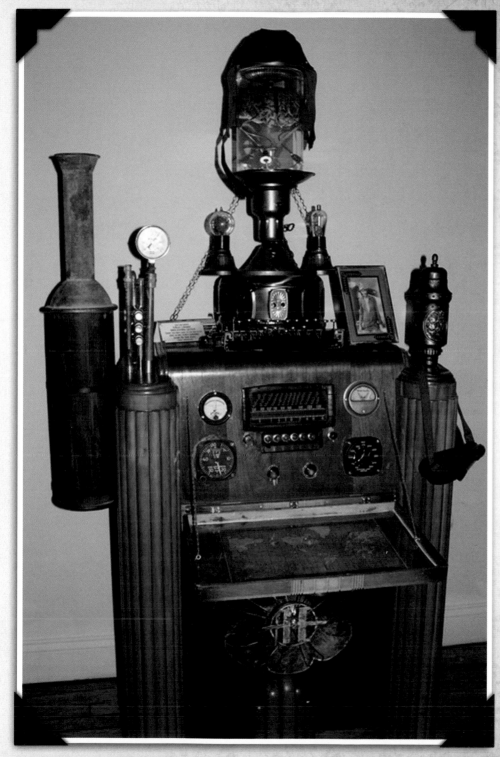

**Left** *The Amelia Earhart Navigational System*, 2009, approximately 6' (1830 mm) tall, found materials dated from 1920 to 1932. Dr. Grymm's functional audio interactive machine replicates the sights and sounds of Amelia, providing navigational instructions to various global paranormal locations from beyond the grave. The machine holds a brain in bubbling liquid, emits "steam," uses lighting effects, and has interactive typing and control panels. Machine design by Dr. Grymm, sound effects by Mark Adams Sound Design, voice of Amelia Earhart portrayed by Pamela Vanderway.

89

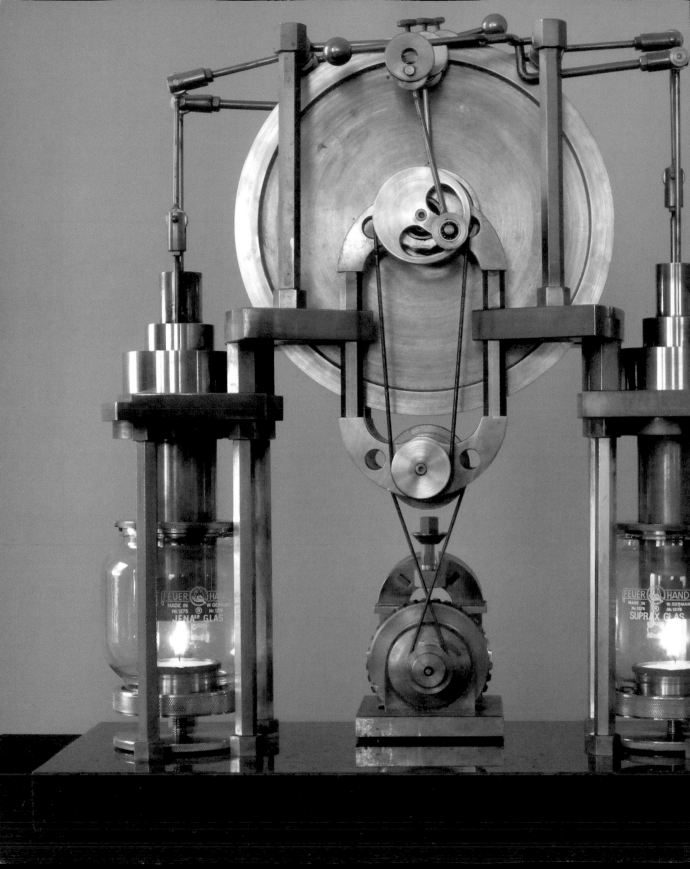

# Jos de Vink

## Bovensmilde, Netherlands

Photo by Hannie
de Vink Henstra

Opposite *Cathedral*,
2004, 15" x 7" x 18"
(380 mm x 180 mm x
450 mm), brass, bronze,
marble. De Vink's
*Cathedral* is not one
engine, but two. This
made its design and
construction one of the
biggest challenges
de Vink has ever
undertaken. The result,
however, is fantastic.
Both hot air engines
incorporated in the
*Cathedral* have enough
power to drive a dynamo
that lights several LEDs
between 1.5 and 2 volts.

After retiring from a career in computer technology, Jos de Vink
still had a desire to learn and create. De Vink's neighbor, who was
an ardent model builder, challenged him to create a hot air engine
that ran only on a tea or wax light. With help from this neighbor
and colleagues in the Metaalhobbyclub Assen, de Vink built a trial
engine using the principles of the first hot air engine built by Robert
Stirling in 1816.

After receiving positive responses about his engine from
members of the hobby club and others at a model exhibition
in the Netherlands in 2002, de Vink to began to build more.

De Vink has created about twenty-seven engines in eight
years and has started construction on several Stirling low
temperature difference (LTD) engines that can run off the
warmth of the human hand.

De Vink designs his engines from scraps of brass and bronze from
a scrap dealer. The machines demonstrate the possibility of moving
large objects using little energy and show different drive techniques
used by hot air engine builders for the past two centuries.

Beyond having a passion for creating Steampunk kinetic art objects,
de Vink desires to bring a love of technique to the attention of a
younger generation.

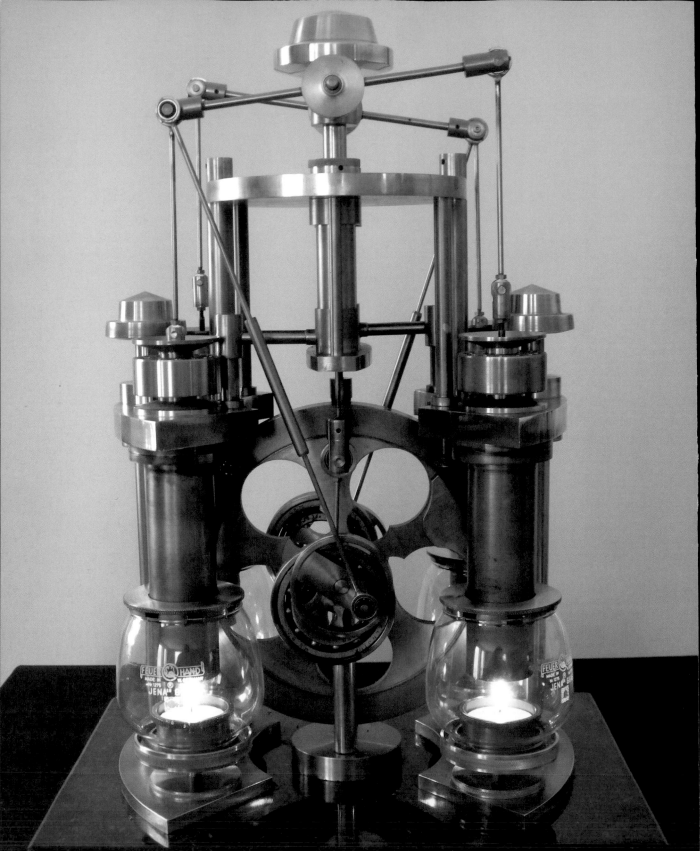

*Basilica*, 2004, 14" x 10" x 20" (350 mm x 250 mm x 500 mm), brass, bronze, marble. While the *Cathedral* consists of two engines, the *Basilica* consists of four. De Vink carefully arranged the engine components so that no one engine would be working harder than another. The result is an incredibly quiet machine. De Vink also developed a cooling system so the engine could run for eight hours on four tea warmers during an exhibition.

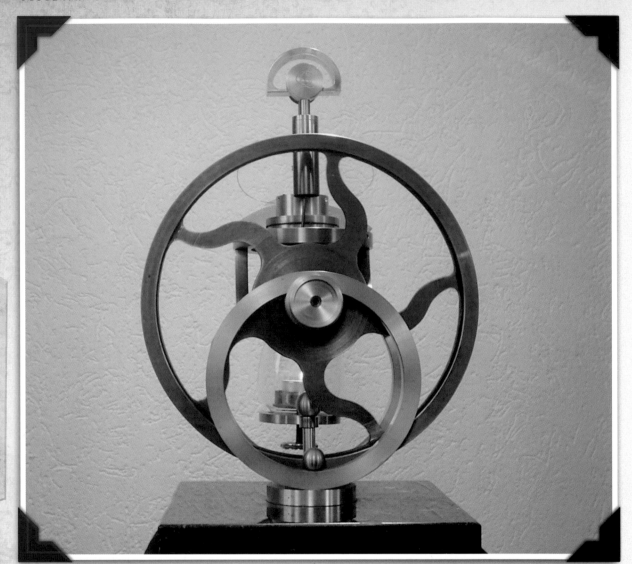

**This Page** *Peacock*, 2007, 12" x 13" x 16.5" (300 mm x 340 mm x 420 mm), brass, bronze, marble. The *Peacock* was modeled after the Ringbom Stirling engine. De Vink's challenge for this project was to make the large heavy flywheel rotate using just the heat of a tea warmer.

**Opposite** *The Flying Saucer*, 2008, 12" x 8" x 14" (300 mm x 200 mm x 360 mm), brass, bronze, stainless steel, Plexiglas. This piece combines three low temperature difference (LTD) engines.

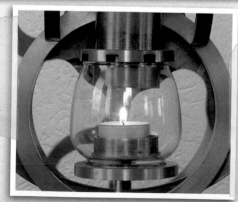

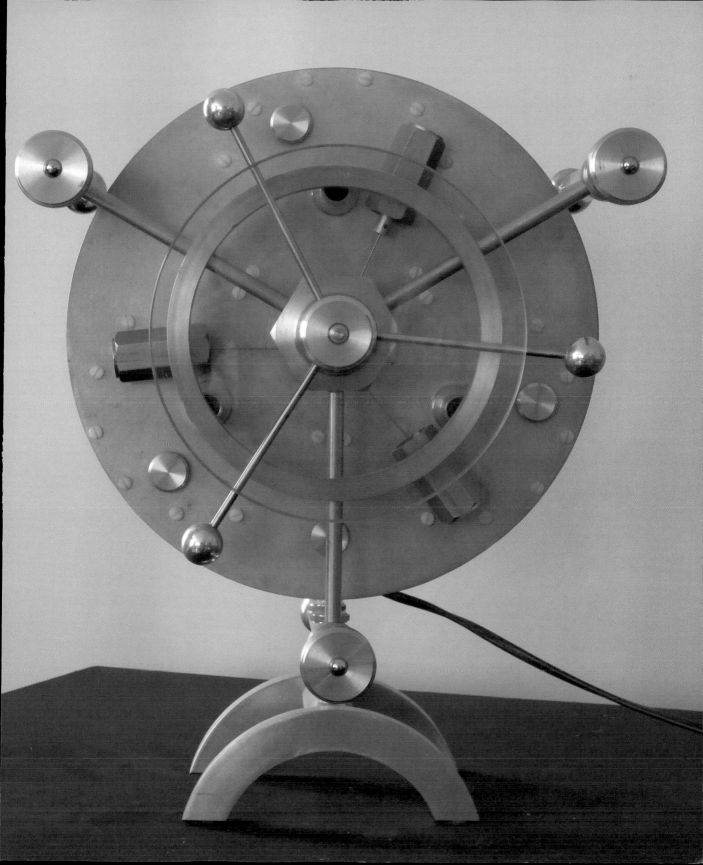

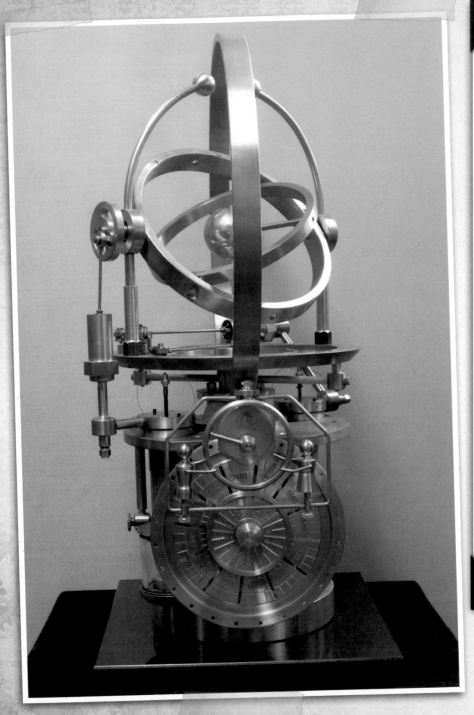

96

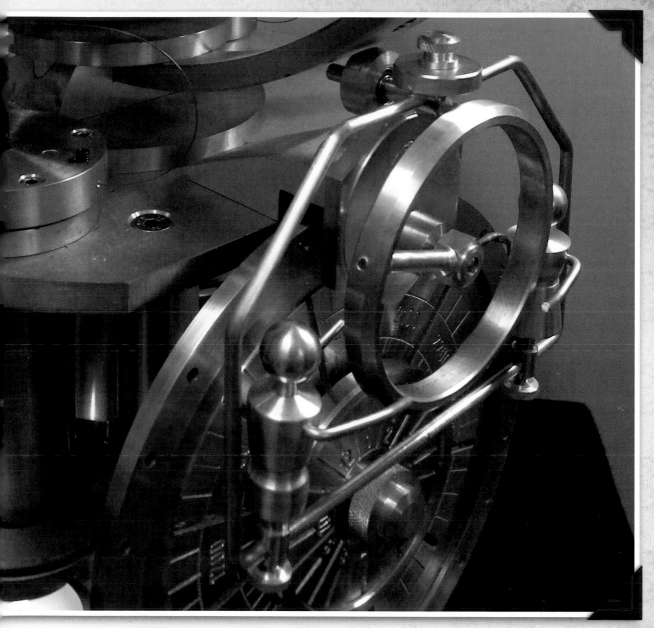

***The Time Machine***, 2010, 16" x 16" x 27" (400 mm x 400 mm x 680 mm), brass, bronze, marble. *The Time Machine* was inspired by some of the instruments de Vink saw at the Museum of the History of Science. It is a combination of two Ringbom engines and cleverly uses springs to reduce the weight of the displacer, allowing the engines to run on a tea warmer or a 20 watt halogen bulb.

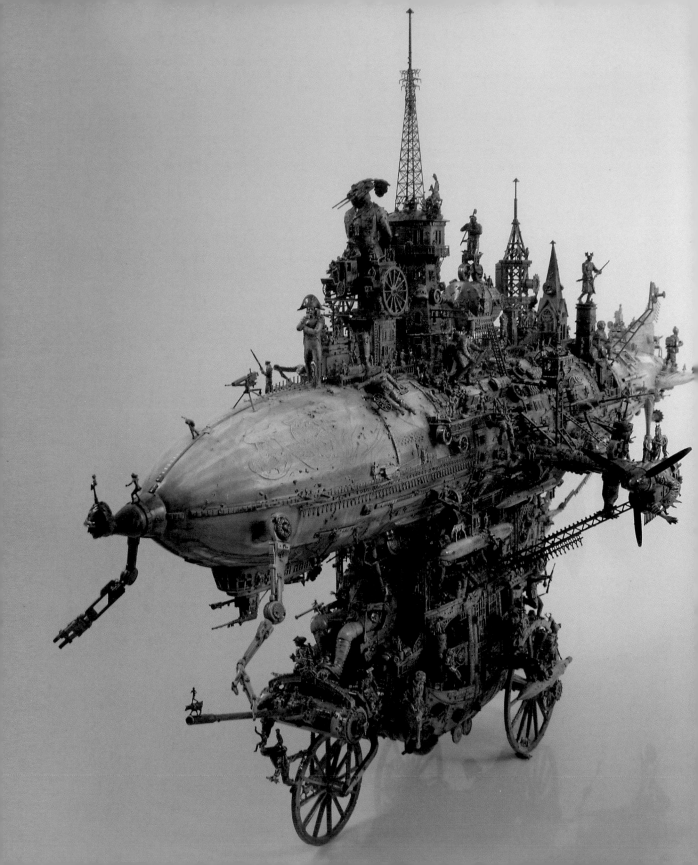

# Kris Kuksi

## Hays, Kansas, United States

Photo by Brandon Worf

Opposite *Caravan Assault Apparatus*, 2009, 28" x 20" x 39" (710 mm x 510 mm x 990 mm), mixed media.

Kris Kuksi's designs are inspired by many things, like the rigidity of machinery and networks of pipes and wires, along with the flowing, graceful, harmonious, and pleasing designs of the Baroque and Rococo periods. And he always strives to add a bit of weirdness or the macabre.

Kuksi had a major emphasis in painting and drawing earlier in his career, and while he enjoyed these forms of creativity, he knew there was something missing. Kuksi recognizes that he has always been a builder, and the creation of his 3-D art is his way of expanding into that realm. He still enjoys painting and figurative work, but he has made sculpture his primary focus.

He says, "Sculptural works are wonderfully intricate constructions of pop culture effluvia like plastic model kits, injection molded toys, dolls, plastic frames, or furniture parts, assembled into grotesque tableaux that look a bit like an explosion in Hieronymus Bosch's attic."

Kuksi has won several awards for his art, and his pieces have been featured in more than one hundred exhibitions, in various art magazines, and on book covers. His pieces reside in the collections of such notable public figures as Guillermo del Toro, director of *Pan's Labyrinth* and *Hellboy;* Fred Durst, musician and film director; Chris Weitz, director of *The Golden Compass* and *American Pie;* Mark Parker, Nike CEO; and Robin Williams, comedian and actor.

99

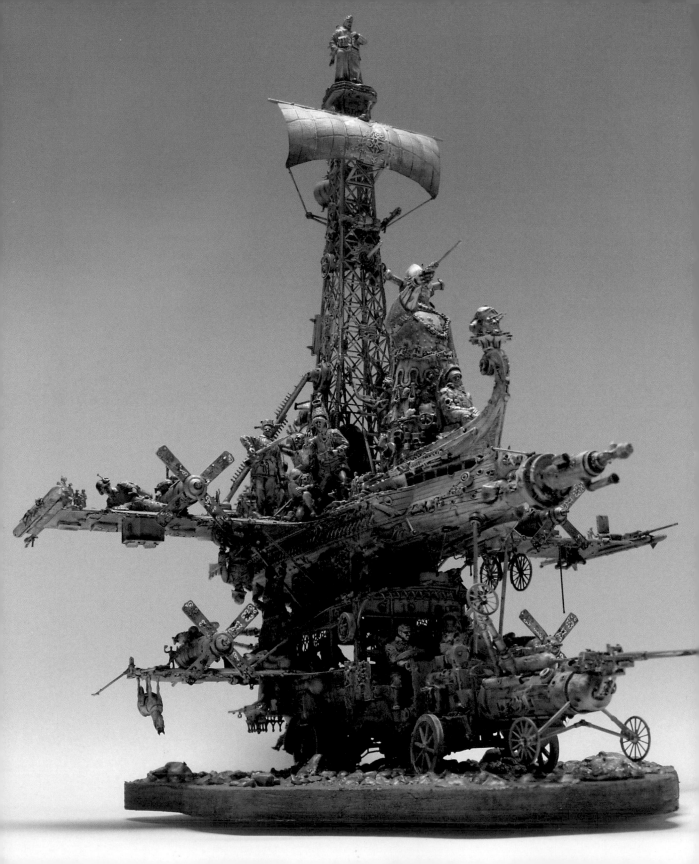

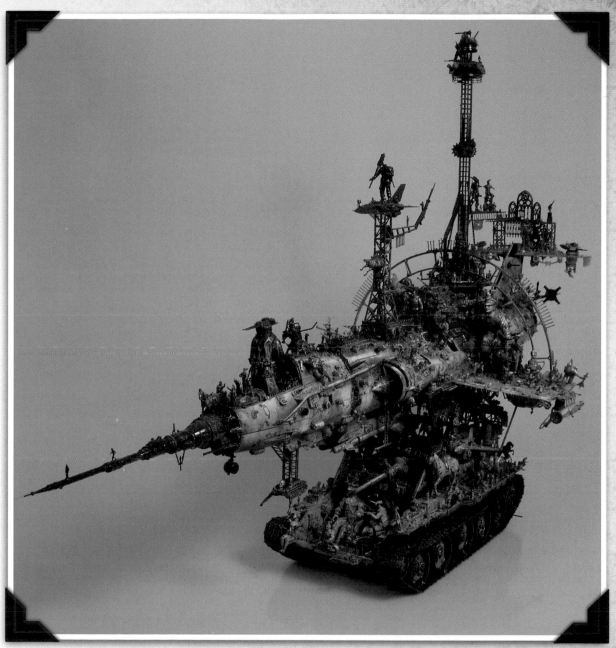

**Opposite**  *Anglo Parisian Barnstormer*, 2009,
18" x 14" x 17.5" (710 mm x 320 mm x 1040 mm),
mixed media.

**Above**  *Sub-sonic Dissidence Propulsion Device*,
2008, 28" x 17.5" x 41" (460 mm x 355 mm x 445 mm),
mixed media.

THE ART OF STEAMPUNK

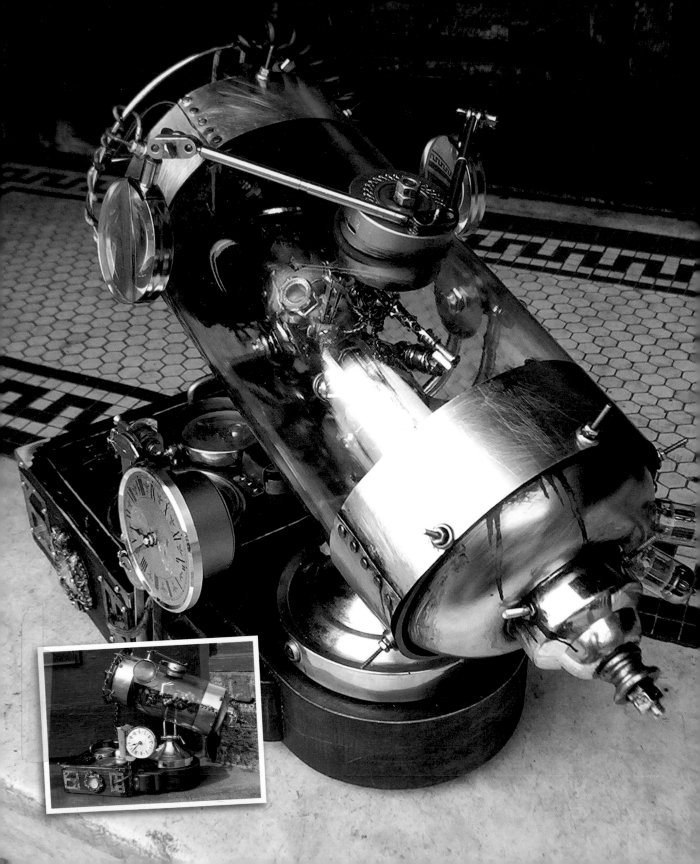

# Molly Friedrich

## PORKSHANKS

### Seattle, Washington, United States

Opposite *Mechanical Womb with Clockwork Fetus*, brass, nickel, steel, copper, acrylic, rubber, plastic, glass. *The Mechanical Womb* explores the possibilities of future technology.

Molly "Porkshanks" Friedrich was born in Brookfield, Wisconsin, in 1975 and attended the Milwaukee Institute of Art & Design and the Minneapolis College of Art & Design before deciding to find her own path as an artist.

Friedrich's work has been noticed by many. She has been interviewed regarding her dimensional travels and her art by the *New York Times*, *Weird Tales*, the *Boston Phoenix*, *Aether Emporium*, the *Gatehouse Gazette*, *BoingBoing*, *Gizmodo*, *Make*, and many others. She has also written articles for websites such as *steampunkworkshop.com* and *instructables.com* and has been honored to create art for the bands Abney Park, Mungus, The Georgetown Orbits, and for the musician Michael Scott Parker.

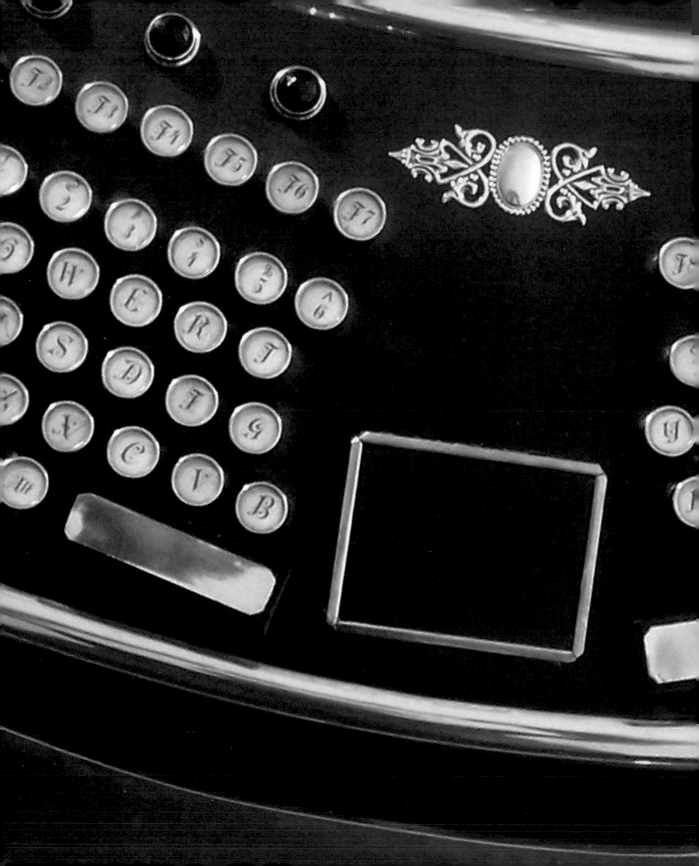

# Richard Nagy

## DATAMANCER
### Chino, California, United States

"Datamancer" is the online nickname of Richard R. Nagy, a California-based artist and entrepreneur, and proprietor of *www.datamancer.net*. Over the last two years, Nagy has been slowly but steadily growing a business that sells Victorian and Art Deco computer hardware, including keyboards, mice, scanners, LCD monitors, and even full PC suites. Although he primarily works with computers, Nagy likes to dabble in almost every medium of design. His work has been featured in the *Wall Street Journal*, *Newsweek*, the *New York Times*, *Maxim*, *IEEE Spectrum*, *Forbes*, the *Boston Globe*, and in dozens of other publications in the United States and abroad. Nagy's work has also been featured on hundreds of Internet sites, including *BoingBoing*, *Gizmodo*, and *Makezine*.

Opposite *Datamancer Ergo Keyboard*, 2009, 23" x 14" (585 mm x 355 mm), brass, leather, typewriter keys. Richard Nagy's elegant *Ergo Keyboard* features acanthus-leaf etchings in the solid brass frame, a black leather faceplate, and padded velvet wrist rests.

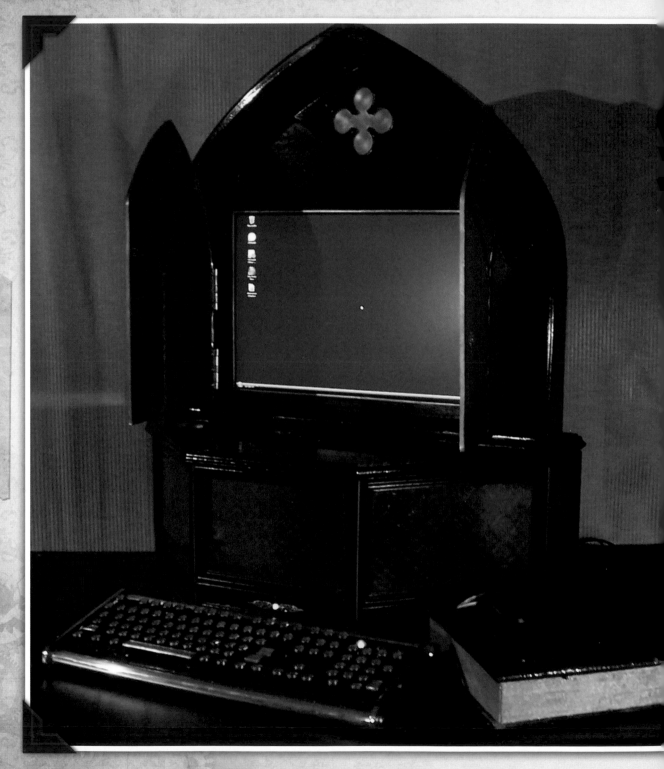

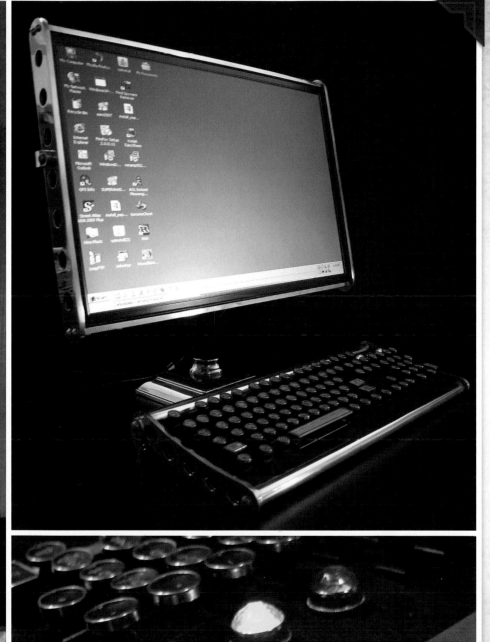

**Opposite**
*The Archbishop*, 2008, 28" x 20" x 36" (710 mm x 510 mm x 915 mm), stained glass, lead, wood, brass. Drawing inspiration from cathedral architecture, this full PC suite includes a custom PC enclosure made of wood and stained glass, an LCD with a gothic arch shape and stained-glass doors, and a gothic-themed keyboard.

~~Left~~ *PC and LCD Combo*, 2010, 24" x 24" (610 mm x 610 mm), brass, leather, typewriter keys. Pictured here is one of Datamancer's brass PC and LCD combos.

~~Below~~ *Aviator Keyboard*, 2010, 19" x 8" (480 mm x 200 mm), aluminum, leather, typewriter keys, mechanical-switch keyboard. This is one of Datamancer's "Aviator" model keyboards.

**107**

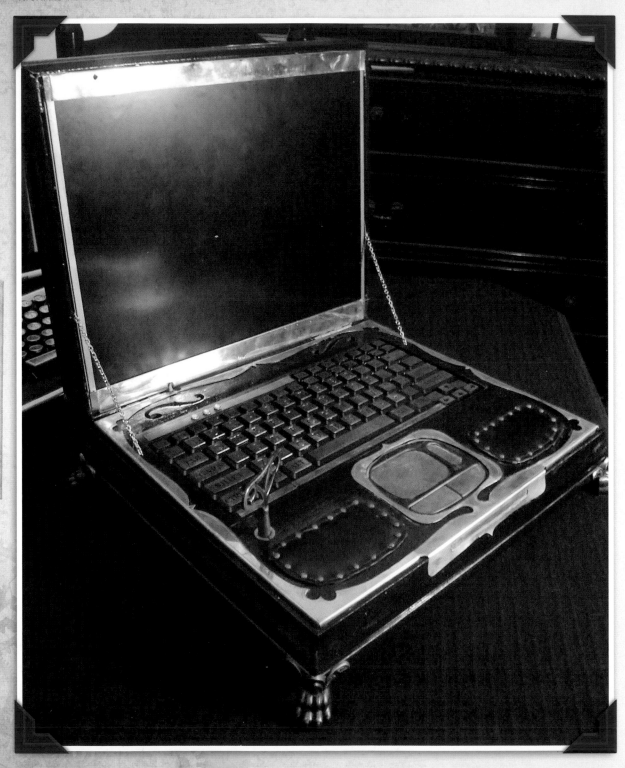

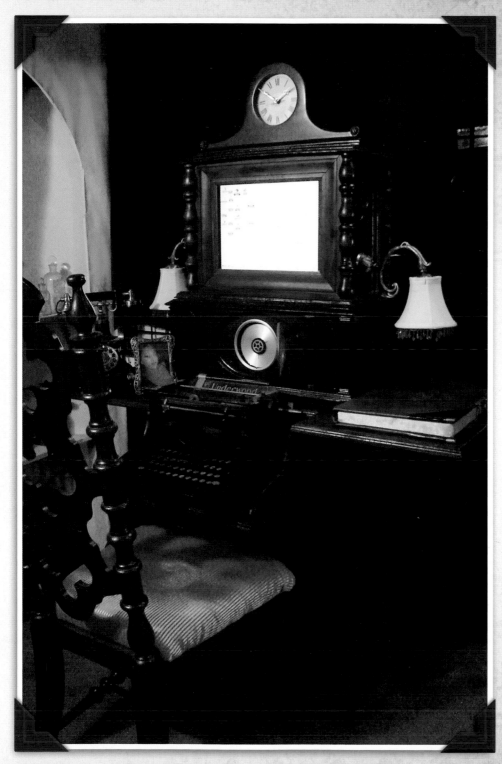

**Opposite** *Datamancer Steampunk Laptop*, 2007, 14" x 16" (355 mm x 405 mm), wood, brass, copper, clock gears, glass. This is a fully functional laptop with a Victorian twist. It features an array of clockworks under glass, engraved copper keys, leather wrist rests, and turns on with an antique clock-winding key.

**Left** *The Nagy Magical-Movable-Type Pixelo-Dynamotronic Computational Engine*, 2006, 48" x 36" (1220 mm x 920 mm), wood, Underwood typewriter, King radio cabinet, assorted PC components. One of Datamancer's earliest projects, the *Computational Engine* features a modified King Radio cabinet, flatpanel LCD, Singer sewing machine legs, and an Underwood typewriter rewired to act as a modern PC keyboard.

# Stephane Halleux

## Mohiville, Belgium

Photo by Muriel Thies

Opposite *Flying Man*, 2010, 39" x 43" x 20" (1000 mm x 1100 mm x 500 mm), mixed media.

Stephane Halleux has come to the conclusion that he does not have much to share about his work: no great theories, no subliminal messages, no great trade secrets. Instead, he will tell you that what he finds himself doing most often when he goes to create another Steampunk masterpiece is attempting to return to a time of childish innocence where anything is possible. It is in this state that ideas and concepts do not have to remain on paper, but can come alive and enter our universe, or any universe they please.

Halleux's life partner has told him she often hears him talking out loud or making strange noises when he is in his workshop. Halleux admits to this because, in reality, he does not work, he plays. That is not to say that nothing serious goes on in Halleux's workshop. He regularly examines and dismantles pieces, sorts through materials, and cleans up after himself, but when it comes to bringing life to his creations, Halleux allows his imagination to have full reign.

Halleux hopes that those who see his creations will enjoy traveling among them just as much as he enjoyed bringing them to life.

111

# The Assistant

## By Stephane Halleux

Once upon a late evening, while cleaning my workroom, I realized how useful an assistant would be—someone I could entrust with all the little tasks that were slowing down my work.

From an old spin dryer and an old German typewriter, I created a robot with pliers for a left hand and a blowtorch, cutting disk, and drill grafted onto its right hand.

This new companion quickly showed himself to be extremely gifted.

He executed any requested work so rapidly that I had great difficulty keeping him busy for more than a few minutes. He soon started to complain about my slowness in creation and low wingspan projects. I told him that things were not so obvious—I suffered from a lack of room, I had a family life. In fact, I'd like to see him try it. My wish was fulfilled right away. My assistant drew up new plans while I was running about looking for the materials he needed. .

A couple of days later, while carrying out one of his numerous projects, he made me understand he would be able to work even faster if I relieved him of all the superficial tasks that prevented the true blossoming of his art. I had become my assistant's assistant!

I smothered him by filling his old spin dryer thorax with linen. Since then, I've been exhibiting his carcass and sweeping out my workroom late in the evening and whistling.

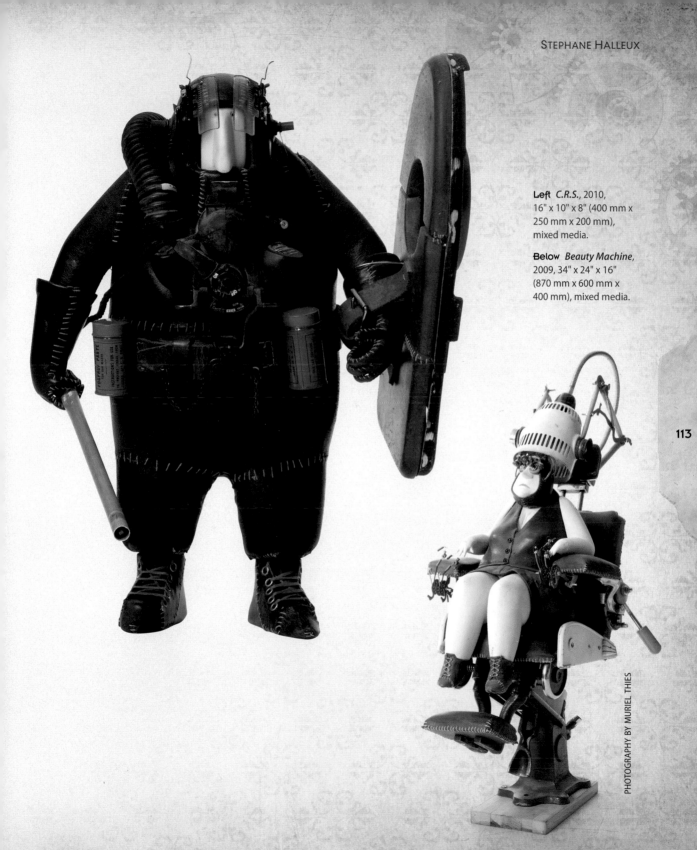

**Left** *C.R.S.*, 2010,
16" x 10" x 8" (400 mm x
250 mm x 200 mm),
mixed media.

**Below** *Beauty Machine*,
2009, 34" x 24" x 16"
(870 mm x 600 mm x
400 mm), mixed media.

PHOTOGRAPHY BY MURIEL THIES

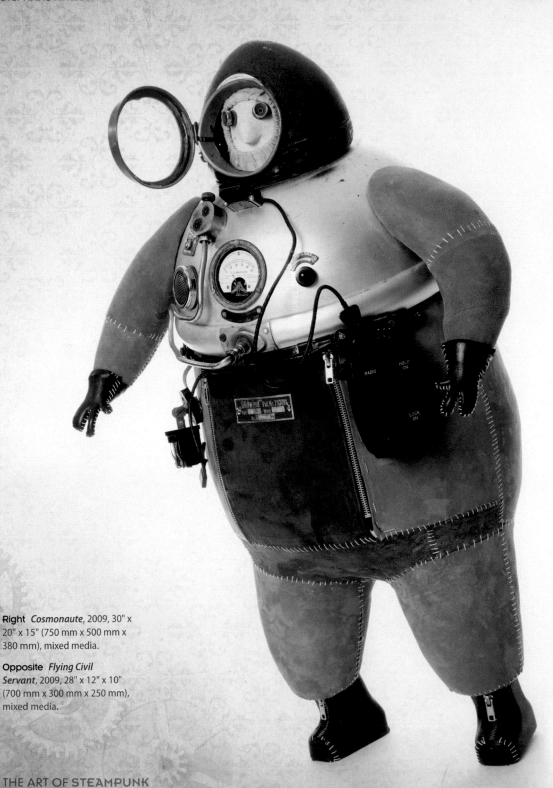

114

**Right** *Cosmonaute*, 2009, 30" x
20" x 15" (750 mm x 500 mm x
380 mm), mixed media.

**Opposite** *Flying Civil
Servant*, 2009, 28" x 12" x 10"
(700 mm x 300 mm x 250 mm),
mixed media.

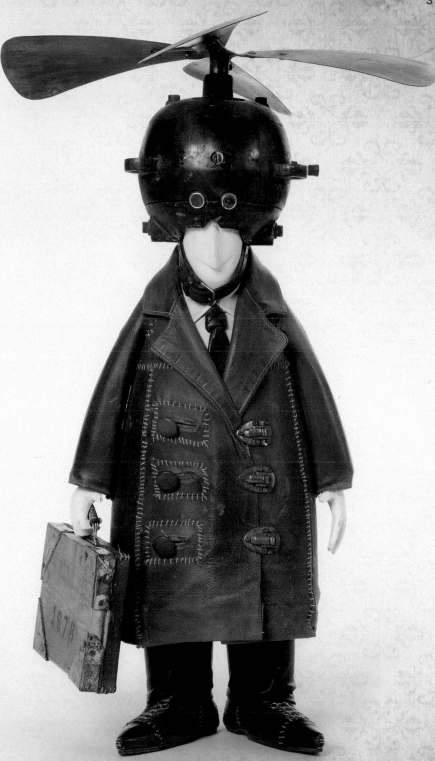

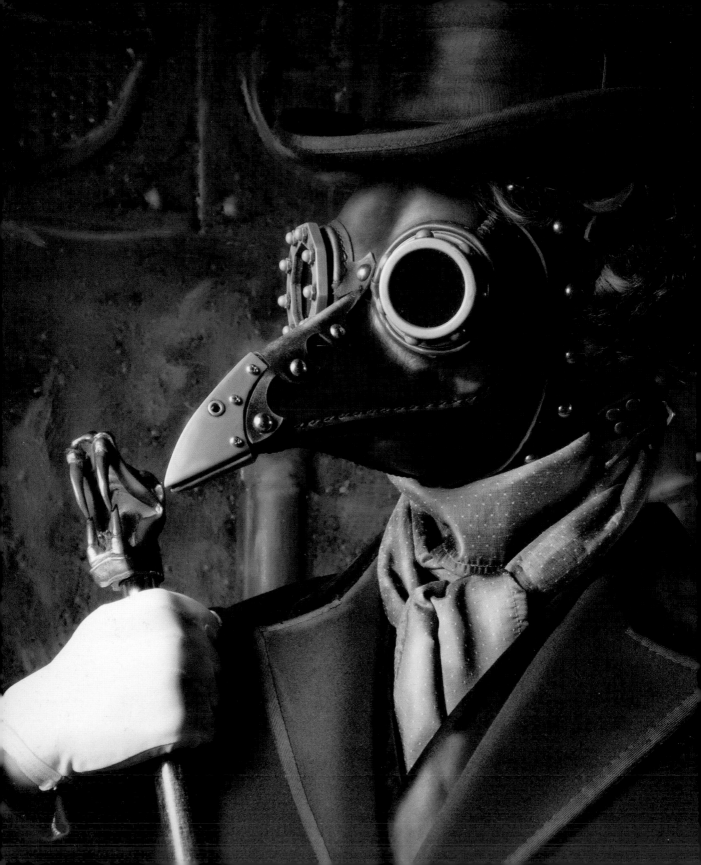

# Tom Banwell

### Penn Valley, California, United States

Photo by Topher
Adam Photography

Opposite *Dr. Beulenpest
Gas Mask*, 2010, leather
and cold-cast aluminum.
This mask is made to
imitate the classic plague
doctor mask.

Tom Banwell is a self-taught artist with no formal training who has dabbled in a variety of media, including batik, woodcarving, mixed media art dolls, and leather working. As a child, he was fascinated by helmets and other hats and would collect them.

As an adult, Banwell started a business designing, making, and selling men's Western leather hats. Later, he built another business casting custom resin pieces, which often required him to imitate other materials, such as bronze, marble, or wood with the resin. Banwell takes this past experience and incorporates it into his current Steampunk artwork.

Banwell finds that the Steampunk genre fits him exceedingly well, combining several of his interests—history, costuming, mechanics, and fantasy—with his creativity in leatherwork. Today, Banwell finds his greatest creative expression in fantasy masks and helmets.

117

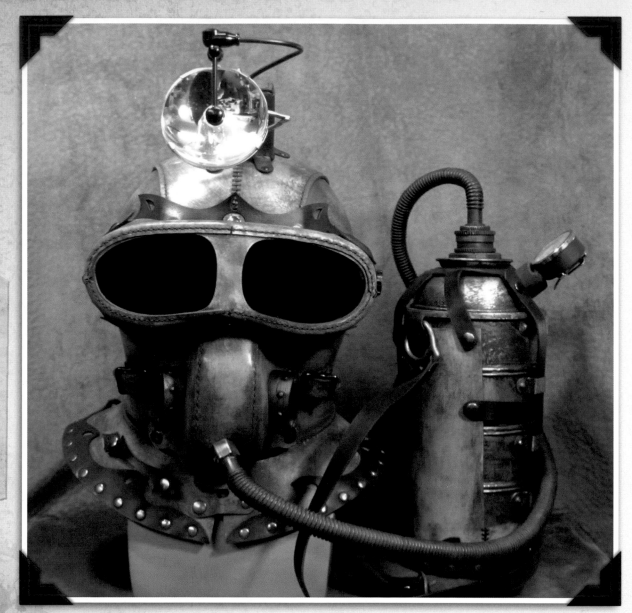

118

**Above** *Underground Explorer*, 2009. The backpack
tank on this mask holds septoxygen, a dense liquid
form of the life-giving element oxygen, which is made
breathable by catalysts within the mask's snout-like
face piece.

**Opposite** The *Underground Explorer* also features
a head lamp and oil lamp that can be used without
the mask.

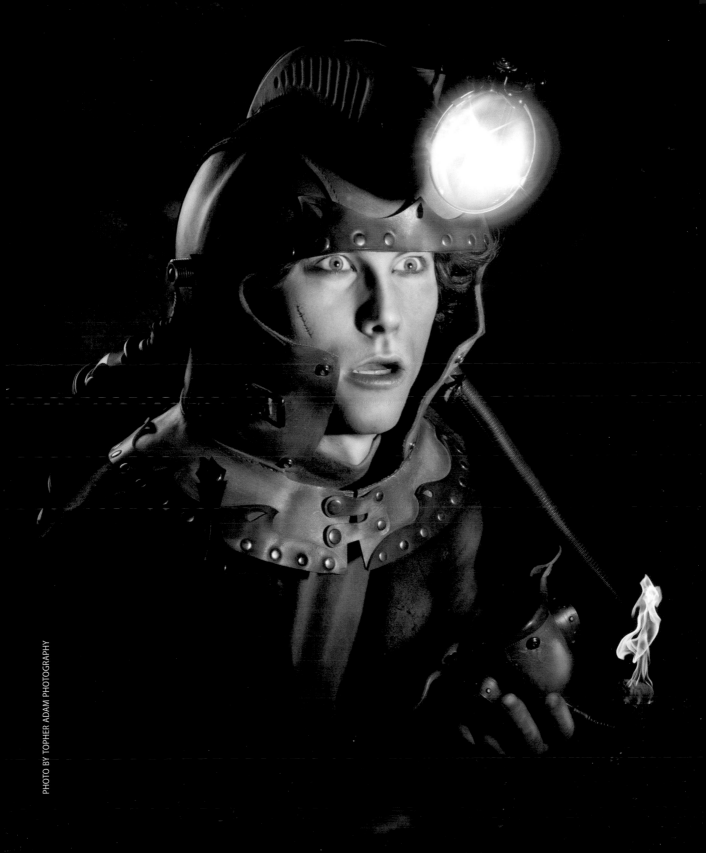

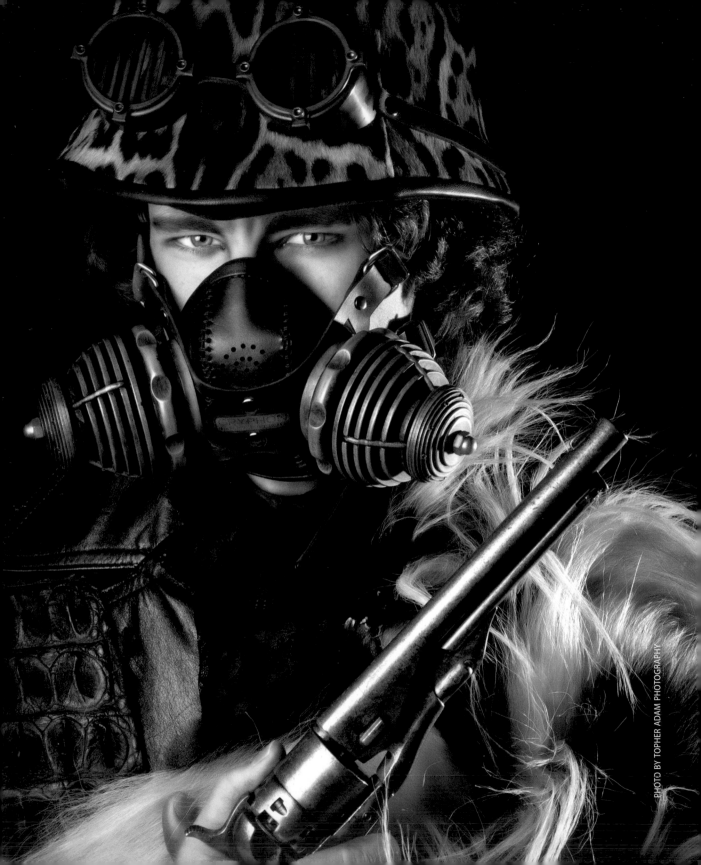

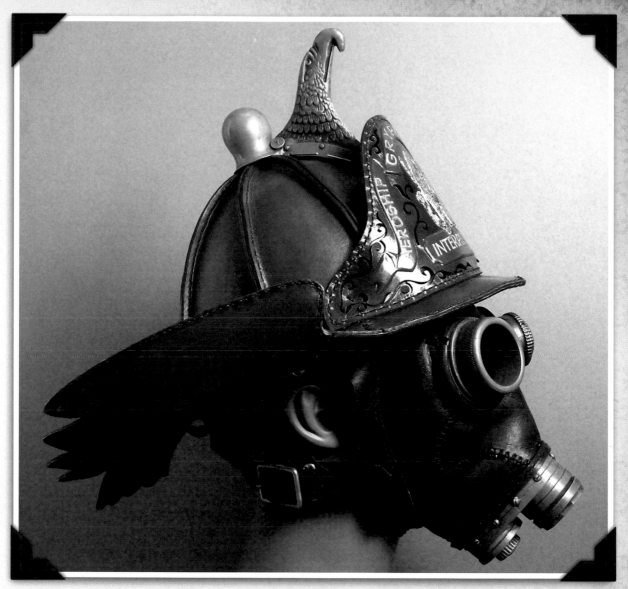

**Opposite** *Bad Air Transmutator* and *Pith Helmet*, 2008. The aluminum canisters on the *Bad Air Transmutator* make the air breathable for this adventurer. Goggles by Gothic Punk Specialty Hardware.

**Above** *Firemaster*, 2008. The *Firemaster* is composed of two pieces: the #43 gas mask and the *Firemaster's* helmet. The brim of the helmet reflects the shape of gryphon wings, while the "tall eagle" finial is similar to those sported by nineteenth century firefighters.

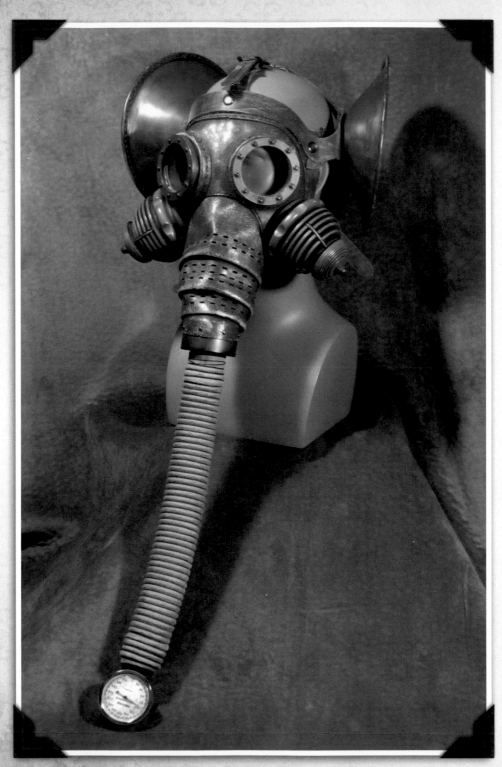

122

**Right** *Pachydermos Gas Mask*, 2009. To create this piece, Banwell covered a vacuum hose with leather.

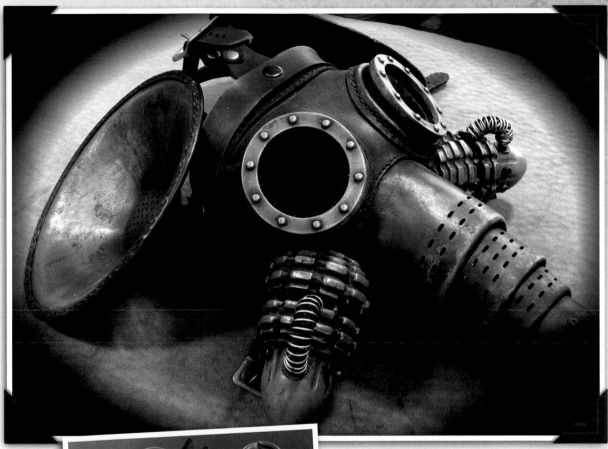

**Above** *Olifant Gas Mask* or *Son of Pachydermos*, 2010, cold-cast aluminum, leather, copper. This mask maintains many of the *Pachydermos Gas Mask's* features, but replaces the long trunk with a custom neoprene hose.

**Left** *Sentinel*, 2010, hand-stitched leather, cold-cast aluminum, metal auditory horn, lamp. Banwell's masks are inspired by the Gryphon Interplanetary Aeroship Expedition, a group of interplanetary explorers Banwell has created and outfitted for their adventures. This mask features the expedition's gryphon logo. The helmet, gas mask, and gorget are each separate pieces.

**Right** *Antiqua Perpetual Calendar*, 1998, created at La Manufacture Janvier (Sainte-Croix), 1.6" (40 mm) diameter, .5" (11 mm) thick, rose gold. The *Antiqua* displays not only the date, but also the day of the week, the current month, and the cycle of the leap year, and automatically accounts for the variable days of each month.

**Below Left** *Classic*, 2000, created at La Manufacture Janvier (Sainte-Croix), 1.4" (36 mm) diameter, .5" (11 mm) thick, yellow gold. Forty-six hand-manufactured rivets decorate the watch case, helping to give this piece its unclassifiable style.

**Below Right** *Trio Grand Date*, 2006, created at La Manufacture Janvier (Sainte-Croix), 1" x 2" x .5" (32 mm x 43 mm x 9 mm), rose gold. Inspired by the appearance of antique steam machine dashboards, Halter includes both hand analog and digital displays on this watch.

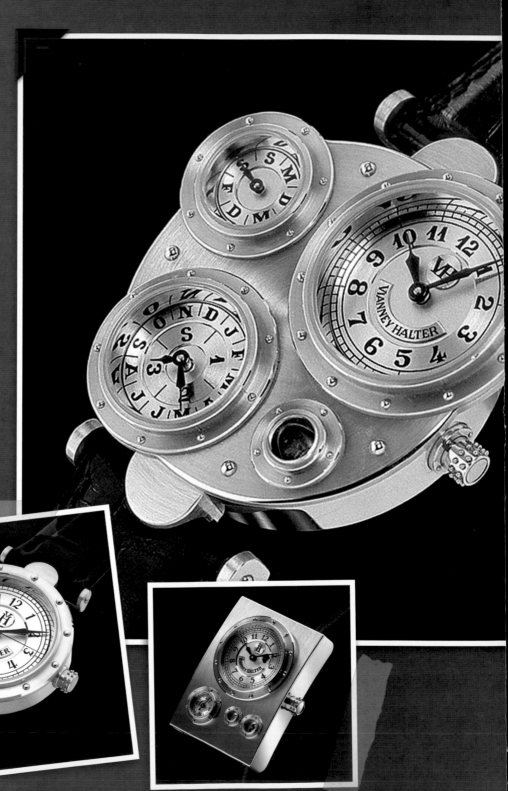

# Vianney Halter

## Sainte-Croix, Switzerland

Photo by
Bernard Cheong

Vianney Halter was born in Suresnes on the outskirts of Paris, France, in 1963. His father was a train driver for the Saint Lazare Railway Station.

In his oldest memories, Halter remembers his father bringing home old machines and mechanisms that fascinated him. Perhaps it was this early exposure to powerful locomotives, steam engines, and control instruments that originated Halter's attraction to mechanics and engineering.

Halter was only fourteen years old when he took the train to the capital to enroll himself at the Paris watch making school.

In 1998, Halter presented a strange watch baptized *Antiqua Perpetual Calendar* at the Basel Fair. This was immediately regarded as a "relic of the future" by the media, who were astonished by this new style.

The *Antiqua* was followed by the *Classic* in 2000 and the *Trio Grande Date* in 2006. These watches form the collection *Futur Anterieur* (past future). The collection is characterized by a display of various functions through riveted portholes.

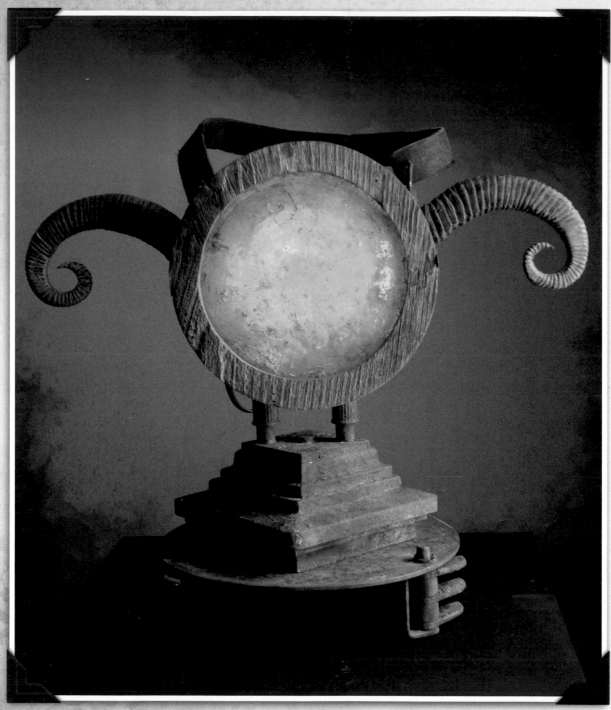

*Steampunk Ram Horn Lantern*, Art Donovan

# INDEX

127

**Acquisition editor:** Peg Couch
**Copy editors:**
Paul Hambke, Heather Stauffer
**Book Designers:**
Lindsay Hess, Jason Deller
**Editor:** Katie Weeber
**Proofreader:** Lynda Jo Runkle
**Indexer:** Jay Krieder